Norbert Schneider

VERMEER
1632–1675

Veiled Emotions

Benedikt Taschen

**This book was printed on 100% chlorine-free bleached
paper in accordance with the TCF standard.**

© 1994 Benedikt Taschen Verlag GmbH
Hohenzollernring 53, D-50672 Köln
Cover and design: Angelika Muthesius, Cologne
Captions: Norbert Schneider, Burkhard Riemschneider
English translation: Fiona Hulse, Newcastle-under-Lyme

Printed in Germany
ISBN 3-8228-9046-4
GB

Contents

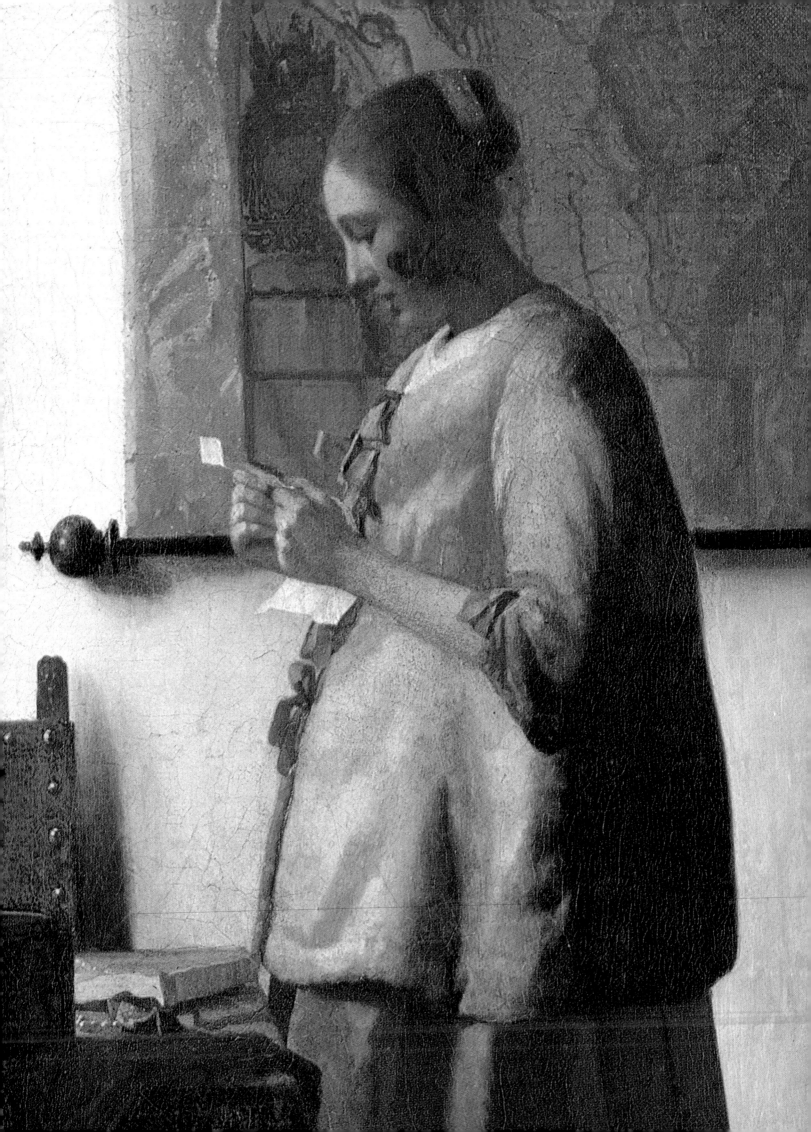

Vermeer of Delft

Vermeer's Life

We know very little about Vermeer's life. There is a tradition that he was baptised in Delft on 31 October 1632, the second child and only son of Reynier Jansz. His father was born in 1591 in Antwerp. In 1611 he moved to Amsterdam where he specialised in the silk trade. He married Digna Baltens in 1615 and settled a short time later in Delft; at that time he bore the name "Vos", and from 1625 to 1629 he leased an inn, the sign of which was a fox, an allusion to his name. He continued to maintain his connections with the silk trade, although he gave art dealing as his main occupation upon being admitted to the Delft Guild of St. Luke in October 1631. This indicates that he followed a variety of trades simultaneously.

J. M. Montias has discovered that Vermeer's maternal grandfather, a watchmaker named Balthasar Claesz. Gerrits, was involved in some shady business deals. From 1619 onwards he and his accomplices used bought moulds to forge coins. This developed into an affair of such proportions that even the Public Prosecutor and Prince Maurit's governor became involved. Two of Gerrits' accomplices were condemned to death and beheaded. Gerrits himself managed to get away, to The Hague, and finally Gorinchem, where he seems to have lived on undisturbed.

An entry in the Nieuwe Kerk registers shows that Vermeer's father bore the name "Vermeer" as early as 1625. In 1641 he bought the "Mechelen" inn, which lay in a good part of the town, on the northern side of the market square, for the sum of 2.700 guilders (not including the mortgage and high interest charges). The inn dated from the 16th century and, with a total of seven chimneys, offered luxurious accommodation. The patrons of Reynier's included members of Delft's refined and affluent bourgeoisie. These social contacts must have made quite an impression on Vermeer.

We know, from a document dated 1640, that Reynier had relations with artists such as Balthasar van der Ast (already famous in his own day for his paintings of flowers), Pieter Steenwyck, and Pieter Groenewegen. It may be that these gave the young Vermeer his first artistic leanings. Nothing is known about his training as a painter. All that we can say for certain is that he was admitted as a master to the Guild of St. Luke on 29 December 1653. This guild included painters in all genres, glass makers and dealers, faience makers, embroiderers and – art dealers, and until 1620 – carpet weavers too.

According to the statutes, a precondition for being admitted was a six-year apprenticeship to an artist recognised by the Guild. It has been suggested that this may have been Leonaert Bramer (1594–1674), but the stylistic differences between this artist (who went to Italy in 1614 and returned to his native town of Delft in 1624) and Vermeer are so great that there has been little support for the theory.

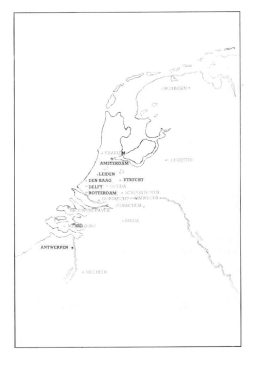

Vermeer's background
Vermeer's father was born in 1591 in Antwerp and moved to Delft shortly after his marriage in 1615. He leased an inn there. However, when he was admitted to the Delft Guild of St. Luke, he stated that he worked as an art dealer.

Woman in Blue Reading a Letter
(detail, see p. 51)
Vermeer's wife
Because she was thought to be pregnant, the *Woman in Blue Reading a Letter* was formerly identified with Vermeer's wife; it is known that she bore fifteen children. However, attempts to work out the identity of this woman are superficial and do not contribute anything to our understanding of the meaning of this picture. The girl is wearing a farthingale which appears to be made of crinoline. This piece of clothing was highly fashionable at the time.

An alternative suggestion has been that Vermeer could have studied with Carel Fabritius (1622–1654; cf. p. 13), who was trained in Rembrandt's Amsterdam studio. Fabritius became a citizen of Delft in 1650, and joined the Guild of St. Luke in 1652. He was killed when the Delft magazine exploded, destroying much of the town. Dirck van Bleyswyck sang Vermeer's praises in a four-line piece in his *Beschrijvinge der Stadt Delft* (Description of Delft), calling him the "masterly" successor of the "phoenix" Fabritius. Although not too much emphasis should be placed on such an isolated comment, it nonetheless confirms that Vermeer was held in no little esteem in his own day.

Vermeer married Catharina Bolnes on 20 April 1653, in Schipluy, a small place near Delft. She was the daughter of Maria Thins, who was at first opposed to the marriage. It may be, given that she herself was financially well off, and given that Vermeer's father was at the time in considerable debt, that she did not consider the marriage to be on a sufficiently secure financial footing. Another possibility is that there were problems at first because of their different religious backgrounds: Vermeer was a Calvinist, while Catharina Bolnes was Catholic. Leonaert Bramer was also a Catholic and put in a good word for Vermeer, and it was thanks to him that Maria Thins finally dropped her reservations. It has often been said that Vermeer caused Maria Thins to think more favourably of him by becoming a Catholic; however, there is no documentary evidence of this.

At first, the newly married couple lived in the "Mechelen", but then moved to his mother-in-law's house on the Oude Langendijk in what was known as the Papists' Quarter, near a Jesuit mission. Vermeer appears to have been relatively well off at this time, as he had no difficulties supporting his growing swarm of children. Catharina bore him fifteen children, though four of them died when still very young. He produced two paintings a year on average and he could scarcely have met these high costs of living from that income alone. There is no

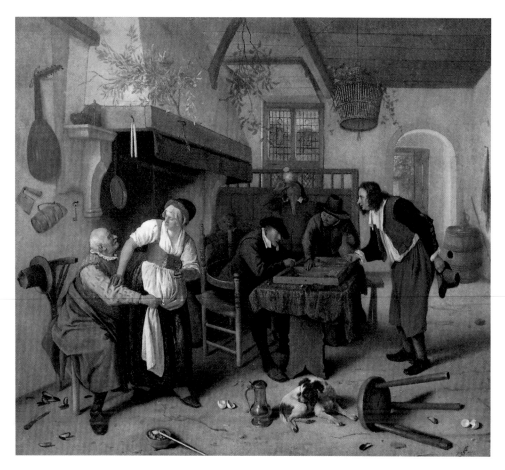

Jan Steen:
In the Tavern, undated
Vermeer was admitted to the Delft Guild of St. Luke in 1653. Besides painting, he also worked as an art dealer. He presumably took over the running of his father's inn, the "Mechelen", once his father died. A contemporary Delft artist, Jan Steen, who leased a brewery in 1654, painted a number of scenes in inns. The situations he paints cannot be relied upon to be completely realistic however, as their intention is satirical.

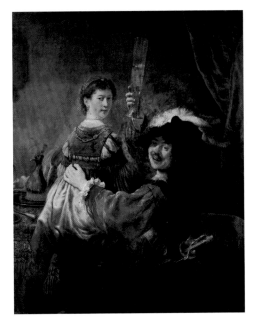

Rembrandt:
Rembrandt and Saskia in the Scene of the Prodigal Son in the Brothel, c. 1636
Brothel scenes in seventeenth-century Dutch art developed from portrayals of the Biblical story of the Prodigal Son. Even Rembrandt used this theme in a portrait of Saskia and himself.

The Procuress (detail, see p. 25)
Possible self-portrait of Vermeer
What is thought to be the only self-portrait of Vermeer can be seen in *The Procuress*.

definite information as to whether he continued to work as the landlord of the "Mechelen", though such a second job was not at all unusual amongst seventeenth-century Dutch painters. We might mention Jan Steen, for instance, who leased the Delft brewery "de Slange" in 1654 (cf. p. 8).

We can be quite certain, however, that Vermeer worked as an art dealer, like his father. He would have earned considerably more money by selling other artists' paintings than by selling his own. But he nonetheless continued to give his occupation as "painter" whenever he signed official documents. This tied in with his registration in the Guild of St. Luke; he twice held the office of *Hoofdman* (syndic) on the Guild's ruling body, from 1662/63 and 1670/71.

Vermeer's relationship with Maria Thins had improved noticeably, as can be seen from the fact that his family moved in with her. Maria Thins was separated from her husband, Reynier Bolnes, the owner of a brickworks, but received a very large income from real estate, stocks and shares, and credit notes. She inherited several farms when her sister Cornelia died in 1661, and she leased out one of them, the "Bon Repas" near Schoonhoven. The extent of Maria Thins' wealth can be seen from a notarial inventory made in February 1676. It is an extensive list of the furniture, clothing and household goods contained in the eleven rooms, cellar and attic. Vermeer's family lived downstairs, and his stu-

Vermeer's home town
In the seventeenth century, Delft was the centre of the Dutch tile industry. Delft potteries were engaged in the attempt to imitate precious Chinese porcelain. Faience made in Delft could be found in households up and down the country.

ILLUSTRATION PAGE 12:
The Glass of Wine (detail, see p. 37)
His mother-in-law's house
Vermeer's family lived in the lower storey of his mother-in-law's house. The solid oak table and the leather-covered chairs, all of which appear in many of Vermeer's paintings, were kept here.

dio, with two easels and three palettes, was on the top floor. The studio contained the heavy oak table which appears in many of Vermeer's paintings, together with the equally familiar leather-covered chairs (p. 12). Maria Thins owned a series of paintings which Vermeer employed as *claves interpretandi*, aids to the interpretation of his own paintings, and these included Dirck van Baburen's *The Procuress* (p. 24), and a picture of *Christ on the Cross*, which is probably the same as the painting that appears in the background of Vermeer's *Allegory of Faith* (p. 80). Vermeer also used items of clothing, such as his wife's ermine-trimmed yellow satin jacket, in his paintings; he sometimes altered their colours, just as he also tended to adapt any household objects included in his sets, adjusting their proportions to suit his purpose.

Vermeer probably painted very little for the public art market, most of his work being produced for those patrons who particularly valued his work. This may also account for the modest number of paintings he produced. One patron was the baker Hendrick van Buyten, who is probably the one whom the French nobleman Balthazar de Monconys visited when the latter stayed in Delft in 1663. He made the following comment in his journal: "I met the painter Vermeer in Delft, but he had none of his own paintings at home. We did, however, see one at a baker's, which had been sold for a hundred livres; I think even six pistoles would have been too high a price." (A pistole was ten guilders.)

Vermeer's other patron was the Delft printer Jacob Dissius, who lived nearby on the Marktveld. Nineteen of Vermeer's paintings are mentioned in an inventory of his property dating from 1682. It is almost certain that the majority of the twenty-one paintings of Vermeer's auctioned by the art dealer Gerard Houet in 1696 in Amsterdam are these very paintings belonging to Dissius.

A clear indication of Vermeer's reputation as an art expert is that he was given what was then considered an honourable commission, to authenticate a

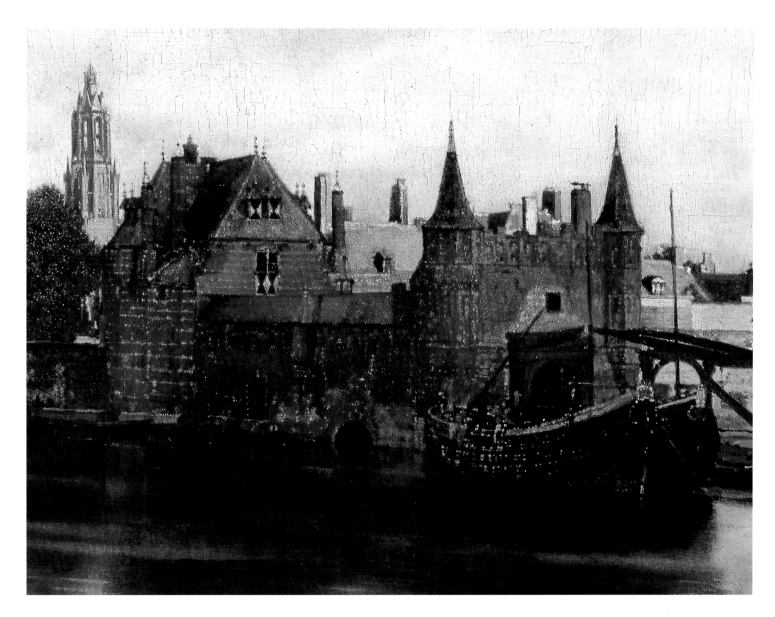

View of Delft (detail, see p. 19)
The Schiedam Gate and the Nieuwe Kerk
The buildings in the foreground, such as the
Schiedam Gate are in shadow, while in the
background buildings such as the Nieuwe
Kerk's tall tower gleam brightly.

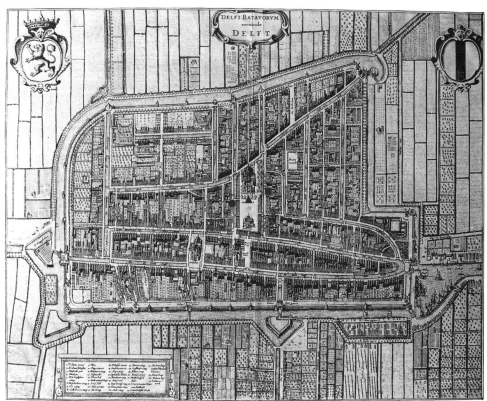

Town plan of Delft from Willem Blaeu's 1649
Town Atlas

- ● The "Flying Fox" Inn, where Vermeer was
 probably born.
- ▲ The "Mechelen" Inn, which was run by
 Vermeer's father, Reynier Jansz.
- ■ The house belonging to Maria Thins, Ver-
 meer's mother-in-law, which he lived in
 with his wife.
- ✳ Position from which Vermeer painted his
 View of Delft.

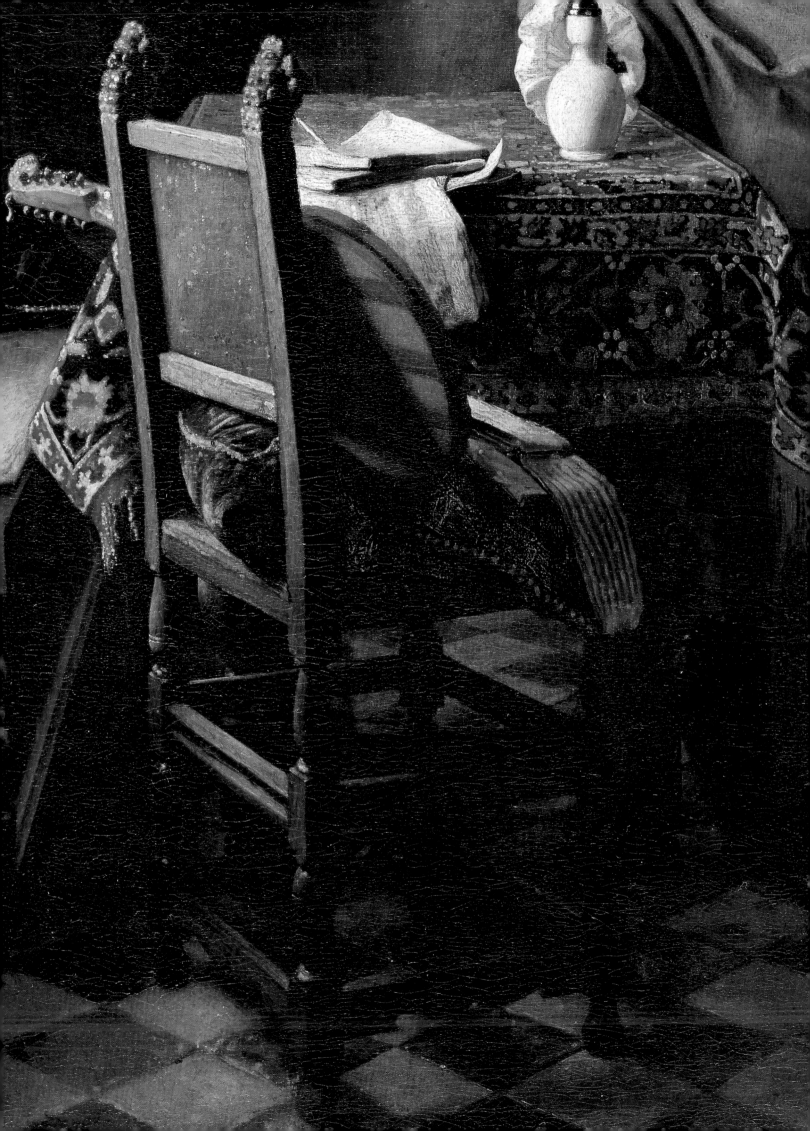

collection of Venetian and Roman paintings which had been sold to Friedrich Wilhelm, the Elector of Brandenburg, by the art dealer Gerard Uylenburgh, for the sum of 30.000 guilders. He rejected the pictures as being "clumsy, slapdash copies". Vermeer journeyed to The Hague in 1672, together with fellow Delft artist Hans Jordaens, in order to contest the ascription of the paintings to Raphael and Michelangelo before a notary. He explained that they were worth at most a tenth of the sum Uylenburgh had asked.

Vermeer's later years were overshadowed by a dramatic deterioration of his personal financial position. He got into debt and had to take out loans. On 5 July 1675, he went to Amsterdam in order to take out a loan of 1,000 guilders. War had broken out between the Netherlands and France in 1672, with French troops advancing rapidly right into the northern part of the United Provinces, and this had had a ruinous effect on Vermeer. Dykes were opened as a last form of defence against the French army, and this flooded enormous tracts of land, including the land that Maria Thins had leased out at Schoonhoven. As a consequence, Vermeer was no longer paid the rent which had, till then, been a regular source of income for his family. That disastrous year became known as the *rampjaar*, and from then onwards Vermeer did not manage to sell any more pictures. His wife later commented on this when talking about the destructive war with France: "Because of this, and because of the large sums of money we had to spend on the children, sums he was no longer able to pay, he fell into such a depression and lethargy that he lost his health in the space of one and a half days, and died."

Vermeer was buried on 15 December 1675, in the family grave at the Oude Kerk, Delft. He was survived by eleven young children, of whom about eight still lived at home. Catharina Bolnes now found herself hardly able to satisfy her creditors, and therefore felt it necessary to apply for the High Court in the Hague to take charge of the management of her properties. She relinquished all her rights of inheritance, ceding them to her creditors. Antoni van Leeuwenhoek (1632–1723; cf. p.75) was appointed trustee of the properties. His main occupation was as a cloth merchant in Delft, and he was already internationally renowned for his inventions and discoveries in microscopy; he was made a member of the Royal Society in London in 1680.

At this time, the only paintings of Vermeer's which Catharina Bolnes still possessed were the picture known as *Schilderconst* (*The Art of Painting*, p.83), and the *Woman with a Pearl Necklace* (p.57). She gave *The Art of Painting* away on 24 February 1676, to discharge her mother's debts. Most of the other paintings were owned at that time by the printer Jacob Dissius, who died in October 1695. Several months after his death, twenty-one Vermeers were put up for auction in Amsterdam.

The 1696 auction catalogue, which included pictures by other artists (a total of 134 pictures were auctioned), is extremely useful, for it shows us that Vermeer was held in high esteem. It is striking that the estimates for his paintings are by no means low when compared to usual prices. For example, number 1 was the *Woman Weighing Pearls* (p.59), which is now in Washington; it was estimated at 150 guilders ("it is painted with great skill and vividness"). The price set at auction for number 31, the *View of Delft* (p.19), was particularly high at 200 guilders. Compare this with Jan Steen, who once received that amount for three portraits, or Isaak van Ostade, who in 1641 sold thirteen paintings to an art dealer for 27 guilders. During his best period, Vermeer was clearly at the top of the price structure of the Delft art market; it is even said that, in or shortly before 1663, he was paid 600 guilders for a painting containing just one figure.[1]

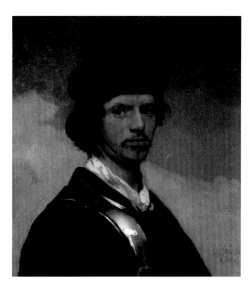

Carel Fabritius:
Self-portrait, 1654
Carel Fabritius (1622–1654), who had been a pupil of Rembrandt's in the 1640s and then settled in Delft in 1650, is generally supposed to have been Vermeer's teacher. Fabritius was killed in the explosion of the Delft magazine in 1654. An obituary describes Vermeer as Fabritius' successor: "The phoenix [Carel Fabritius] has departed from this world/ In the midst of life and fame/ A new master has arisen from the ashes/ Vermeer will follow in his steps."

Register of the Delft Guild of St. Luke, c.1675
The register of the Guild of St. Luke is one of the few documents to contain any information about Vermeer's life. Vermeer's name is entry 78, and Carel Fabritius, who is thought to have been his teacher, is entry 75.

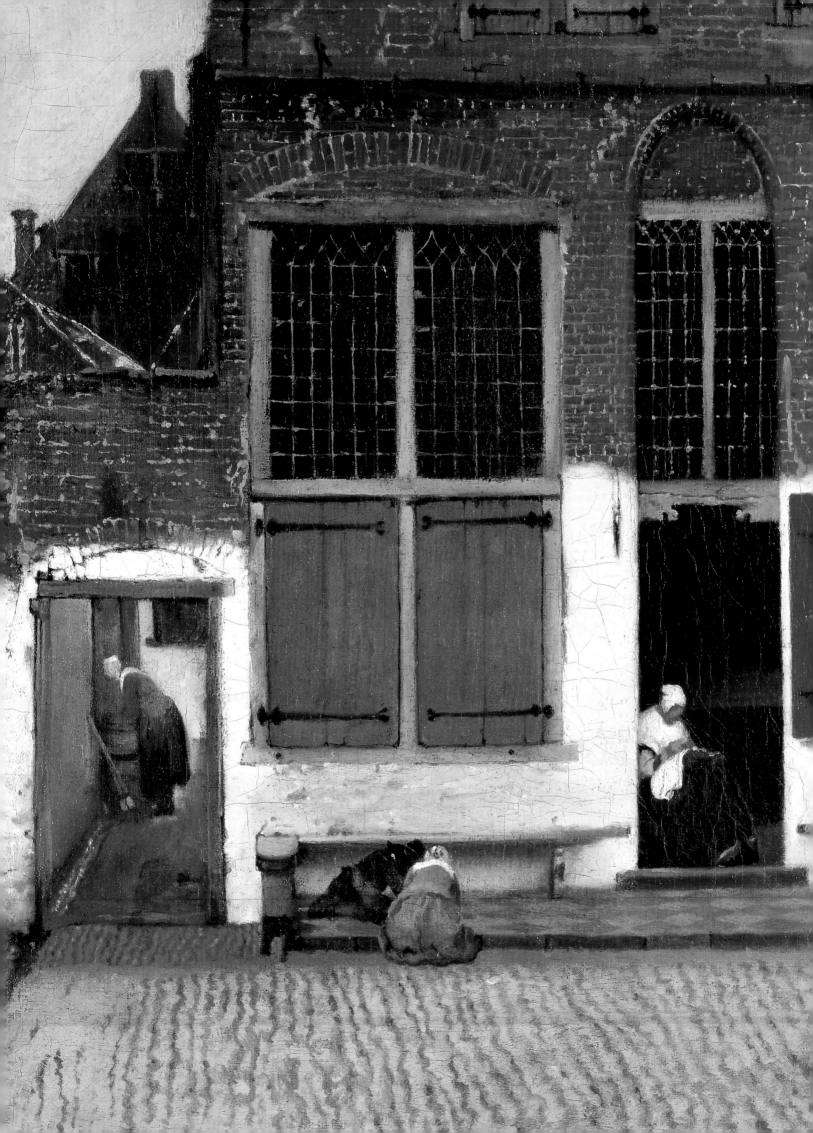

Views of Delft

The City and the Streets

Vermeer twice painted aspects of his home town of Delft. One such painting, kept in the Rijksmuseum in Amsterdam, is the small picture generally known as *Het Straatje* (*Street in Delft*, p. 17); the other is the considerably larger *View of Delft* (p. 19), in the Mauritshuis, The Hague.

Views of towns were not often painted for general sale in Holland, most of these pictures being official or private commissions. The prices that they fetched frequently greatly exceeded those paid for uncommissioned landscapes. In 1651, for instance, Jan van Goyen received the sum of 650 guilders from the city elders for his view of The Hague. The average price for ordinary landscapes has been shown in research carried out by J. M. Montias to have been about 16.6 guilders.[2] The auction catalogue of the pictures sold after Vermeer's death, on 16th May 1696, includes number 32, a view of Delft estimated at 200 guilders; this is a comparatively high price. It has been assumed that Vermeer planned his *View of Delft* using a camera obscura (cf. p. 18). Willem Blaeu's 1649 Atlas, which contains town plans of Delft, has been used to identify the precise point, the upper storey of a house, from which Vermeer painted this picture. A relatively high viewpoint can be inferred from the angle at which we look down at the group of people on the banks of the Schie. The gentle diagonal of the river bank in the foreground is a compositional feature that can also be seen in Esaias van de Velde's *View of the Zierikzee*. It was Pieter Bruegel the Elder who first introduced this triangular piece of shoreline into Dutch landscape art.

Taken as a whole, however, Vermeer remains faithful even here to the basic principle that informs his interiors, that of strong linear structures. It is his preference for this orthogonal type of composition that differentiates his *View of Delft* so strongly from town views such as those by Gerrit Berckheyde and Jan van der Heyden; they attempt to reveal the secret life of the town by such means as streets that disappear into the background.

Vermeer also attempted to give his painting a unifying colour scheme. Ochres and browns predominate, occasionally highlighted by red and yellow accents, such as the slate roofs that, depending on the positions of the clouds, are partly lit by the sun. Jacob van Ruisdael aimed at similar light effects in the middle distance. In Vermeer's picture, the closer parts of the fortifications, such as the Schiedam Gate, are in deeper shadow, whereas the more distant buildings in the centre, including the soaring tower of the Brabant Late Gothic Nieuwe Kerk, gleam with an almost unreal brightness. It is safe to assume that Vermeer was making a deliberate political point by doing this, because the Nieuwe Kerk had, since 1622, housed the monument, made by Hendrick de Keyser, to William of Orange. William had been assassinated in the Prinsenhof in Delft in 1584, and was held in great respect by the citizens of Delft for his heroic role in the resistance to Spanish rule.

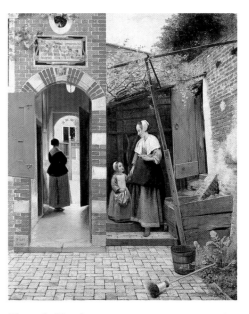

Pieter de Hooch:
Maid and Child in a Courtyard, 1658
Pieter de Hooch (1629–1683) worked in Delft for a time, and was also a painter of domestic scenes. It is likely that Vermeer was familiar with his paintings, including this scene set in a back courtyard; we can see straight down the hallway to the lady of the house, who is watching whatever is happening out on the street.

Street in Delft (detail, see p. 17)
Children at play
Earlier Dutch artists, such as Pieter Bruegel the Elder, were very precise in their depiction of children at play, which for them had a moral purpose; in contrast, on Vermeer's painting, we are left in doubt as to what exactly the children are doing.

An earlier version of the *View of Delft* as revealed by x-ray examinations
Thanks to modern x-ray technology, it is possible to make out earlier sketches below the oil paint. We can see here that Vermeer originally intended the towers in the *View of Delft* to be reflected in the water.

Street in Delft, c. 1657–58
The façade of the house runs parallel to the frame in this painting. Vermeer paid special attention to the signs of ageing on the coarsely whitewashed brick façade. Though the overall impression is one of silent immobility, there is plenty of movement in the clouds passing overhead.

The dark buildings near the banks of the river are studded with tiny, granular dots of colour that make the cracks in the brick walls and the hulls of the ships such as the one near the crane on the right positively shimmer, breaking up their dark bulk. This aesthetic aspect of the picture is directly linked to the image seen through the camera obscura which Vermeer was using. So his topographical view of Delft can even, to a certain degree, be termed abstract, as the optical phenomena associated with this instrument – such as particular types of reflections and refractions and a lack of focus – are reproduced here at several points.

Vermeer was just as interested as Jacob van Ruisdael in the ever-changing clouds, which constantly altered the light falling on his subjects; and time plays an important role in this picture, too. The overall impression, paradoxically, is of calm and a lack of activity, however; this is undoubtedly linked to the near-deserted appearance of the place.

The *Street in Delft* (p. 17), which was probably painted at a somewhat earlier date, also conveys the impression of a timeless, silent lack of motion. We see, directly parallel to us on the other side of the road and beyond the rows of cobblestones, a brick façade with deep-cut, embrasure-like gables, which are lower on the left, forming a link to the neighbouring house. The gables and roofs of buildings further away can be seen over the connecting wall. Most of the house's shutters are closed, which almost gives the impression that the house is sealed off from the outside world. Our only view of the interior is through the open front door, where we can see a woman busy lace-making; beyond her, all is dark. The gateway to the yard has been repaired in a rather rough and ready fashion, and through it we can see a narrow passageway where a maid is busy at a water butt or something similar. This is a motif that was to gain prominence in the work of Jean-Baptiste Siméon Chardin. The two women, who are completely involved in their housework tasks, are anonymous. The maid is partly turned away, so that we cannot make out her face, while the features of the seated woman are little more than a blob of paint framed by the white of her bonnet, upper garment and pillow lace; this colour is continued through the coarse whitewash of the lower part of the façade. It is not possible to make out the faces of the two children kneeling on the ground in front of the house. It is also not clear what they are doing. They are probably engaged in the same sort of activity as the children one sees in Dutch 17th-century church interiors, helping to dig tiles out of the floor.[3]

There is no communication between the few people in Vermeer's *Street in Delft*. Their quiet activities are all separate and independent of each other; nonetheless, we are invited to notice the parallel, simultaneous nature of these activities. The effect is similar in the somewhat earlier 1658 painting by Pieter de Hooch called *Maid and Child in a Courtyard* (now in the National Gallery, London; p. 15). Vermeer was probably familiar with this painting. On the left, the lady of the house can be seen in the hallway that leads onto the street; on the right, quite separately, her young daughter is stepping out of a shed with the maid.

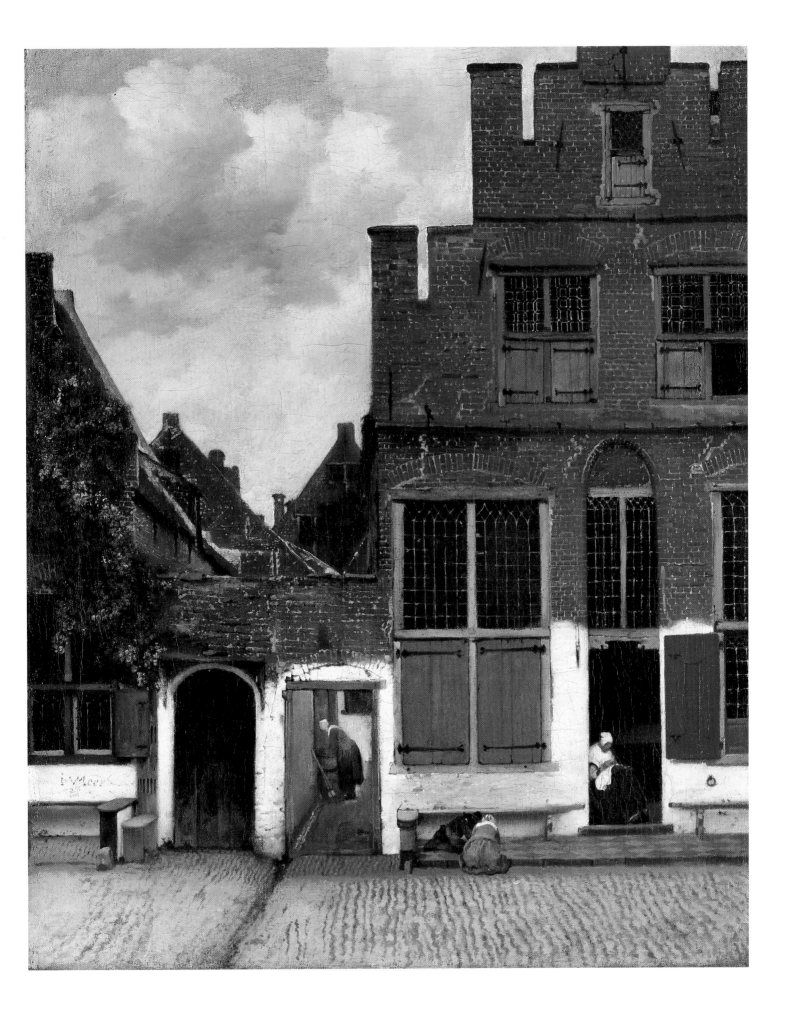

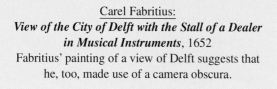

Carel Fabritius:
***View of the City of Delft with the Stall of a Dealer
in Musical Instruments***, 1652
Fabritius' painting of a view of Delft suggests that
he, too, made use of a camera obscura.

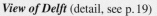

The camera obscura
The general principle of the camera obscura
had been known since classical times, but it
was not used until the sixteenth century, and
then mainly for topographical reasons. A port-
able version was quickly developed, which
projected the image onto a piece of paper or
glass plate, from which the image could be co-
pied onto another medium. Vermeer probably
used such an instrument while painting his
View of Delft.

View of Delft (detail, see p.19)

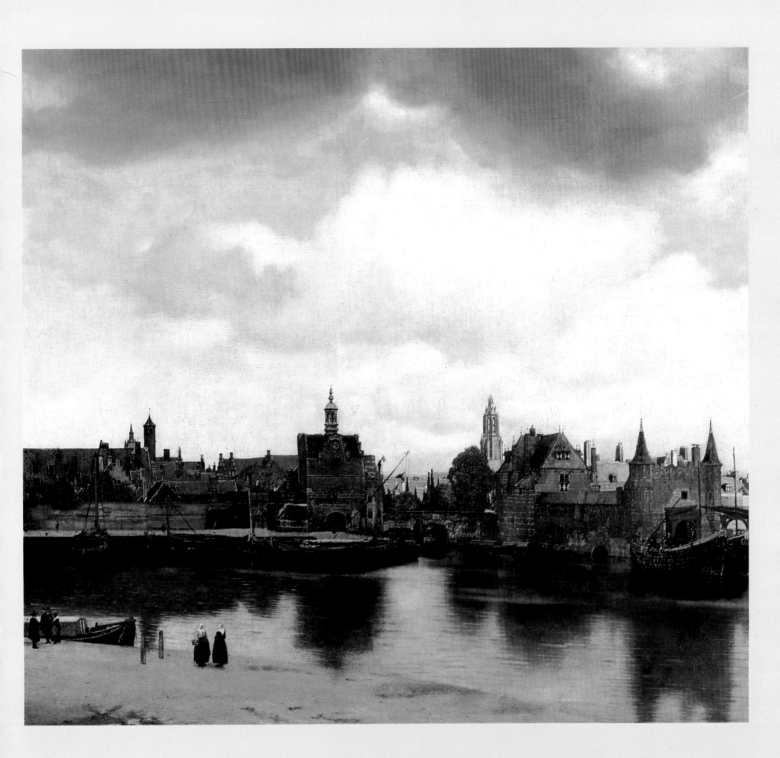

View of Delft, c. 1660–61
It is thought that this view of Delft was painted from the upper storey
of a house. Contrary to the practice of veduta painters, who were interested in
topography and would have painted the town in its entirety, he painted only a
small section. It is safe to assume that Vermeer was making a deliberate political
point in the way he painted sunlight breaking through the dark clouds and striking
the buildings in the background. The Nieuwe Kerk is brightly lit; since shortly after the
turn of the century it had housed the tomb of William I of Orange, a monument
steeped in national symbolism.

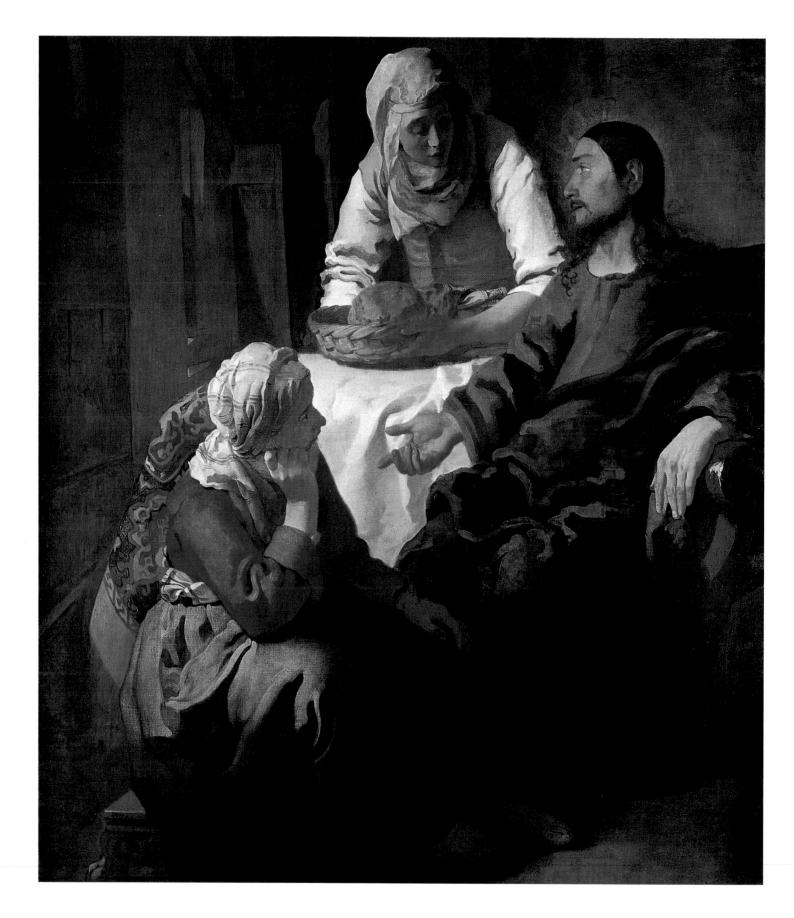

Christ in the House of Mary and Martha, c. 1654–55
This was one of Vermeer's earliest paintings. Paintings of biblical themes
were classified as histories, which were described in treatises on art as
most distinguished tasks. Vermeer probably wanted to demonstrate his
abilities in this genre upon entry to the Guild of St. Luke.

"Mary has chosen the good portion"

History painting: a most distinguished task

Given the many genre paintings done by Vermeer, it is perhaps surprising to realise that the earliest of his works known to us are of the type of paintings known in his time as histories. It apparently seemed important to the young artist (or it was expected of him) to prove that he possessed the abilities of a *pictor doctus*, an "educated artist", upon his admission to the painters' guild; such an artist would be able to inform what the art world considered to be lofty subjects with decorum, in a proper and becoming manner.

The Paris College of Art set the standards, and had developed a hierarchical structure of genres; history paintings occupied the top position – above portraits, landscapes, still lifes and animal paintings. Dutch art critics such as Karel van Mander (*Het Schilderboeck*, Haarlem 1604, folio 281a) stated from quite early on in their treatises that history paintings were the most distinguished tasks in art. On the one hand, this genre included religious subjects, biblical motifs or scenes from the saints' lives and church history; on the other, it also included ancient historical subjects and mythological themes.

In contrast to many works of Vermeer's late period (such as *The Lacemaker*, c. 1669–70, 24.5 x 21 cm and thus Vermeer's smallest painting; p. 63), *Christ in the House of Mary and Martha* is a relatively large painting (160 x 142 cm; p. 20). It depicts a New Testament scene from the Gospel of St. Luke, where the evangelist tells us how Christ went to a market, and was invited home for a meal by a woman called Martha. While Martha was busy in the kitchen, her sister Mary listened to Christ. Martha asked Christ why he did not ask Mary to help her serve, but he answered, "Martha, Martha, you are anxious and troubled about many things; one thing is needful. Mary has chosen the good portion, which shall not be taken away from her."

This section was already extremely popular in sixteenth-century Flemish art. It allowed people to deal with the problem of good deeds, which had been rejected by the Reformers as being superficial. At the same time, it was possible to demonstrate the humanists' favourite contrast, namely that of the *vita activa* (busy, active life) as opposed to the *vita contemplativa* (contemplative life).

Vermeer's *Christ in the House of Mary and Martha* uses a triangular composition that is comparatively straightforward and uncomplicated. The setting is a simple room with wooden walls. Mary is sitting at the front, on a low stool, at the feet of Christ; his head is surrounded by a weak halo, and he is seated on an armchair with voluted arms. Martha is bringing in a basket of bread, and he is showing her, by pointing his outstretched hand at Mary, that the latter has chosen the better portion. Mary has taken off her shoes; this is a sign of humility. Her posture – or, to be precise, the way she is supporting her head on her hand – is in accordance with the iconography of melancholy. Here it stands for pensiveness and spiritual contemplation, in the sense of the *vita contemplativa*.

Christ in the House of Mary and Martha
(detail, see p. 20)
Strong colour contrasts
Vermeer loved strong colour contrasts. The bright white tablecloth contrasts sharply with Mary's vermilion blouse and Christ's blue robe.

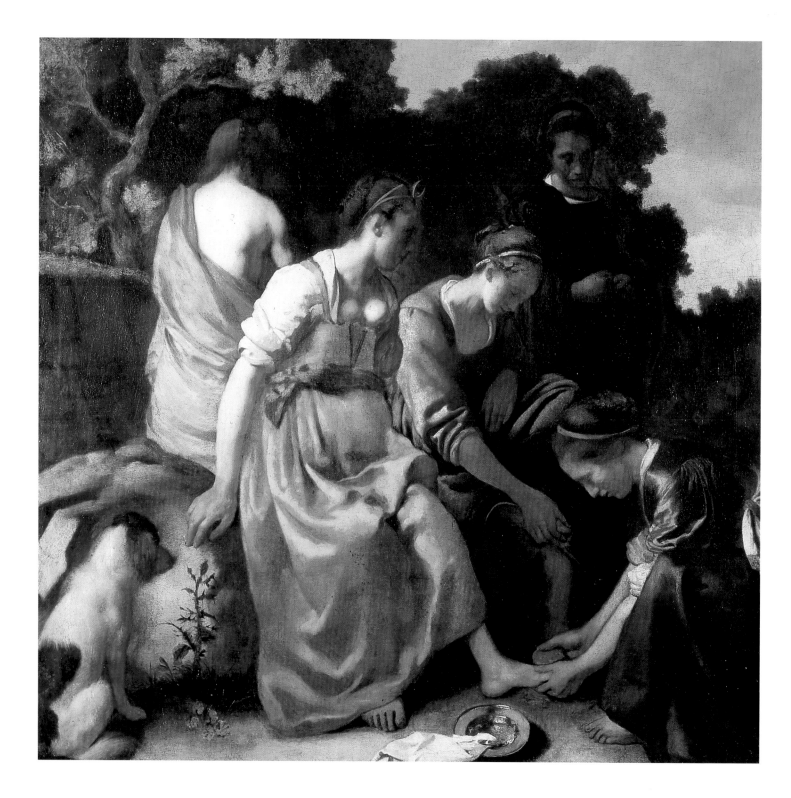

Diana and Her Companions, c. 1655–56
This is another early work by Vermeer that is classified as a history, though the theme on this occasion derives from mythology. Diana was the Goddess of Hunting and was considered to be the personification of chastity. This painting may contain a reference to a picture by Jacob van Loo (1614–1670).

Vermeer applied the colours pastose with a wide brush. This can be seen particularly clearly at the folds in the garments, which are raised roughly. He favoured strong, intense colour contrasts, such as the dazzling white of the tablecloth, strikingly contrasted with Christ's dark blue robe and Mary's vermilion blouse.

Vermeer's second history painting from his early period is *Diana and Her Companions*, now in the Mauritshuis, The Hague (c. 1655–56; p. 22). The theme is borrowed from Ovid's *Metamorphoses* (3, 138–253). In Roman mythology, Diana was the goddess of hunting, and she was considered to be the embodiment of chastity. The motif of the bathing goddess was a particularly good way of demonstrating this aspect of virgin purity, strict morality and the sense of shame, which is being offended by the voyeurism of the approaching Actaeon.

In 1559, Titian painted this later scene – which, according to Ovid, takes place immediately after the episode depicted by Vermeer – for King Philip II of Spain.[4] His subject was nudity, which was at that time beginning to be considered an embarrassing subject. Paradoxically, the artist's liberal portrayal invites voyeurism on the part of his audience, but this is inherently condemned within the picture. In contrast to Titian's erotic and sensual interpretation of the subject, Vermeer's painting seems to lack action and is positively prudish. This tendency to conceal nudity, which was considered to be offensive, can also be seen in the earlier 1648 painting by another Dutchman, the Amsterdam artist Jacob van Loo. It is possible that this painting was one of Vermeer's sources. In Vermeer's painting, a partially clad nymph (behind Diana, who can be recognised by her crescent-shaped diadem) is turning away modestly.

Vermeer depicted only a small number of people in this picture. Diana and two of her companions are sitting on a stone, resting after the hunt. In the background is a darkly-clad nymph, who is reverently, even somewhat apathetically, watching the ritual action that another nymph is carrying out, that of washing the goddess's feet. This motif is used by Vermeer to create a typological connection between Diana and Christ, which gives the painting an almost religious dimension. There is another parallel to this in the washing of Bathsheba's feet (2 Samuel, 11), which was painted at almost exactly the same point in time by Rembrandt (p. 23).

Dusk is beginning to fall, and a heavy, melancholy mood is weighing on this evening scene. The faces of the women are in shadow. This darkness can be associated with the fact that, in classical mythology, Diana was often equated with the moon goddess, Selene (hence the crescent diadem). She was also considered to help with births, as the moistness of the moon was thought to aid delivery.

This early painting still has many faults and weaknesses, in particular where the depiction of the positions and movements of the bodies are concerned. There is no overlooking the qualitative difference between this and Jacob van Loo's painting, the latter being much more elegant in terms of its composition and execution. Measured against high academic standards, Vermeer's composition makes a clumsy and provincial impression. There have long been doubts as to whether this is really one of Vermeer's works, doubts that cannot be completely dispelled. For instance, the painting was ascribed to Nicolaes Maes, who was trained in Rembrandt's studio, when it was bought by the Mauritshuis in 1876. In addition, John Nash has noticed a "distinctly Rembrandtian air"[5] about the painting.

Scene in a brothel

The Dresden painting *The Procuress* (p. 25), on the other hand, is free of any such inadequacies. Vermeer changed genres in this painting, dated 1656. Wheelock has assumed that the artist was inspired to use this subject matter by the painting of the same name by the Utrecht Caravaggist Dirck van Baburen (1590–1624); it was owned by his mother-in-law, Maria Thins, and appears as a reference on the walls of several of his interiors (p. 24).

Vermeer's picture belongs in the category of *Bordeeltje*, brothel pictures, which was greatly valued as a sub-category in Dutch genre painting. The great interest that was shown in such themes indicates that the public was finding a way of compensating for an increasingly prudish moral code. These *Bordeeltjes* derive to a large extent from paintings of the Prodigal Son (filius prodigus), who is in the inn, frittering his money away on whores (Luke 15, 11 ff.) This scene very frequently appeared in prints in the sixteenth century, in versions such as those by Lucas van Leyden and the *Sorgheloos* series by an anonymous artist (Amsterdam, 1541). Originally, Christ's parable of the Prodigal Son was used to demonstrate the contrast between Catholic principles and the Reformers' view of

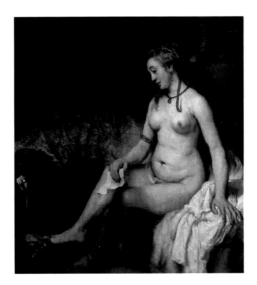

Rembrandt:
Bathsheba with the Letter of King David,
1654
An analogy of Vermeer's scene of Diana's feet being washed (p. 22) is this picture by Rembrandt, which was painted at about the same time. This motif produced a typological relation between Diana and Bathsheba, and Christ.

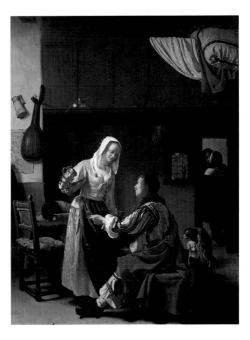

Frans van Mieris:
The Soldier and the Prostitute, 1658
Copulating dogs play an important role in determining the meaning of this scene.

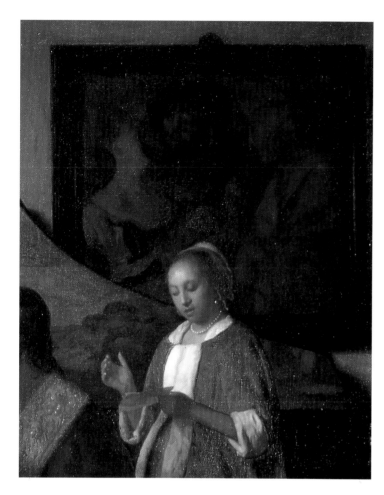

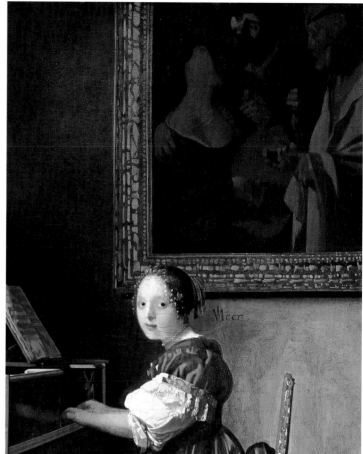

Dirck van Baburen:
The Procuress, 1622
This painting by Baburen, which is set in a house of ill repute, belonged to Vermeer's mother-in-law. It appears, as a painting within a painting, in two of Vermeer's paintings, and was, in addition, probably the stimulus for his own painting of the same name.

TOP LEFT:
The Concert (detail, see p. 40)

TOP RIGHT:
Lady Seated at a Virginal (detail, see p. 43)

the principle of divine mercy, shown when the lost son is received with loving forgiveness by his father.[6]

The motif of the brothel proved fascinating; it is not surprising, therefore, that it quickly developed into an independent genre. From a humanist point of view, it was possible to combine it with the didactic warning that one should learn from such paintings, how easily one could be fleeced in public houses. Warnings against fraud, cheating, and theft also occur frequently in stories about fools; an example is Sebastian Brant's *Narrenschiff* (Ship of Fools), which appeared in 1494. These writings also warned of the consequences of alcoholism, because it reduced one's vigilance, and would ultimately lead the drinker to poverty.

The majority of genre paintings were not simply naive depictions of reality, but always conveyed norms and values in a way that altered what was happening. This painting is no exception, and the subject here is the problem of controlling sensuousness, that one should always be vigilant and sober. The motif of alcohol – or, to be precise, of drinking wine – is a central element of Vermeer's painting. The table in the picture is parallel to the frame, and acts as a barrier between the observer and the participants in the scene. It is covered by a carpet, and a carafe is placed to the right. The young woman wearing the yellow jerkin is holding a wine glass in her left hand, as is the reveller on the left side of the picture; he is clothed in dark burgundy.

The actual theme here is that everything can be bought, including love. The wine has brought colour to the young woman's cheeks, and she has opened her hand to receive a coin in payment for her services from a cavalier, who is wearing a hat decorated with feathers and a vermilion jerkin. It has yet to be shown to what extent this is a brothel scene in the narrower sense. A piece of lace work can just be recognised where it has been put down on the right on the table carpet, and this is a striking feature. It makes it possible to infer that this is most

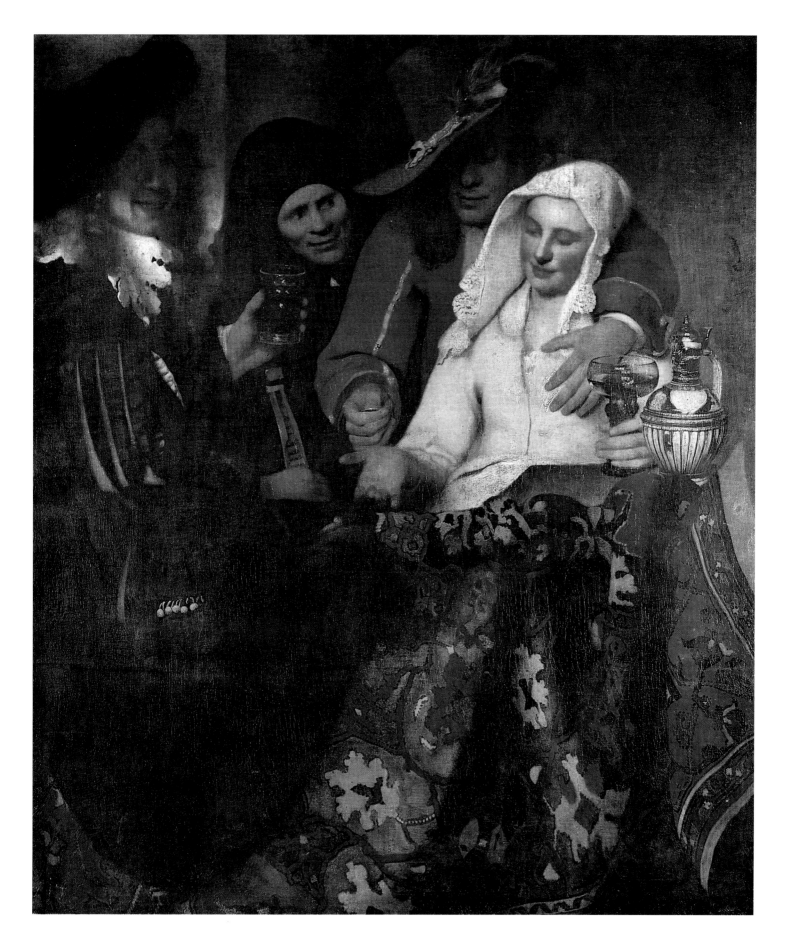

The Procuress, 1656

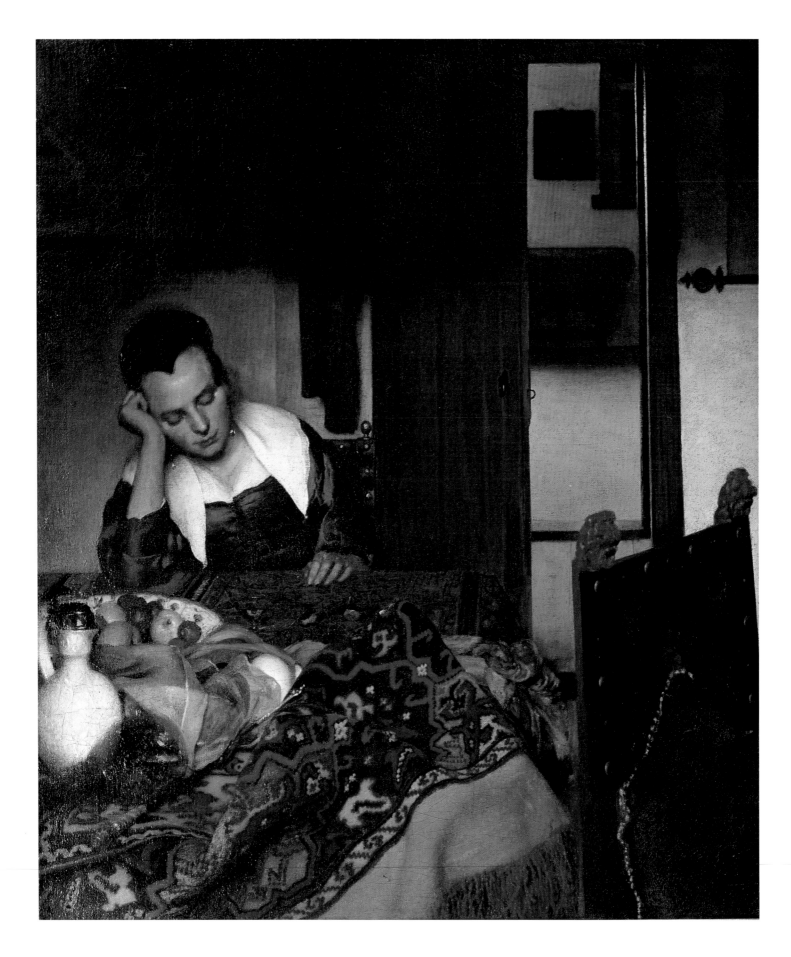

Girl Asleep at a Table, c. 1657

If the quality of the clothing is anything to go by, this is the lady of the house. The way
she is supporting her head on her hand was a traditional motif which signified acedia, or sloth;
here this is due to drunkenness, as the carafe of wine in the foreground tells us. This woman has
been neglecting the household duties entrusted to her.

likely a domestic scene. In that case, what is happening here is that an extra-marital love affair is being initiated with the help of the procuress, who is dressed in black; she is probably an old woman living in the vicinity, who has come to witness the successful conclusion to her efforts. Vermeer's picture, which gives us a close-up view of the scene, is restrained and semantically rather more open in structure when compared to other paintings on a similar theme, such as Frans van Mieris' *The Soldier and the Prostitute* (1658, The Hague, Mauritshuis; p. 23). They tend to fill out the plot with more detail, and occasionally include some quite graphic allusions; dogs are copulating in Mieris' painting.

A drunken girl asleep at a table

As can be seen from the carafe on the left of the picture, the theme of drinking wine is taken up again in this painting of a young woman, which is now in New York (p. 26). A young woman, leaning her head against her right hand, is sitting opposite us at a table. The table is covered with a heavy oriental carpet, the fore-most part of which is arranged in a disorderly fashion to form a pyramid. The girl is obviously asleep. Indeed, when the painting was sold in Amsterdam on 16th May 1696, it was given the title *Een dronke slafende Meyd aen een Tafel* (A drunken girl asleep at a table); when sold again in 1737 it was described as *Een slapent vrouwtje, van de Delfse van der Meer* (A sleeping young woman, by Van der Meer of Delft). If the elegant clothes are anything to go by, she is not a maid, but a *huisvrouw*, or in other words a wife who is in charge of the household.

Vermeer uses very few elements in his pictures, in contrast to Jan Steen, for example, who fills his pictures with a profusion of objects and (usually noisy) participants (cf. p. 8). The woman is isolated from anything that might be happening elsewhere. X-ray examination has shown that there were originally other elements in this painting which Vermeer later painted out: initially, there was a dog in the doorway, and a man in the room beyond. By painting out these narrative additions, he made his composition easier to interpret. The woman's gestures are not so clear, however. They could be considered signs of melancholy, like those of Mary in the earlier history painting. It is more likely, however, that this is a reference to the traditional motif of acedia, or sloth, which was frequently represented in this way.[7] In mediaeval theology, acedia was considered a vice, even a mortal sin. This was an age in which the authorities were constructing a rigid, ascetic work ethos, complete with norms which extended right into the home; for a wife to violate these norms must have seemed to be a direct violation of God's law. In the literature of seventeenth-century housefathers, it was expected that the "housemother", as the commander of the household, would be god–fearing and virtuous, a shining example of Christian virtues and a model for the riff-raff.

Acedia was frequently explained to be a consequence of alcoholism. In his London painting *The Consequences of Immoderation*, Jan Steen depicted a woman who had drunk herself to sleep on wine.[8] Sleeping means that she is neglecting her duties: the household is all topsy-turvy, the children are letting the cat nibble a pie, the maid is giving the parrot a drink of wine, and a couple of lovers are amusing themselves in the garden. So the sacred household order has been annulled. The acedia motif appears at a lower social level in Nicolaes Maes' painting *The Lazy Maid* (p. 27). Here it is the maid who has made free with her master's wine and has therefore not been able to carry out her tasks. That this is the case is made clear by the untidy pile of crockery on the floor, and the cat, who is snatching away a plucked hen.

The intake of wine on the part of Vermeer's sleeping young woman evidently

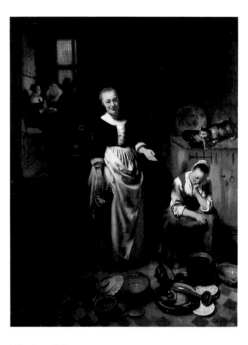

Nicolaes Maes:
The Lazy Maid, 1655
In this painting, it is the maid who has drunk too much wine and is neglecting her duties.

TOP LEFT:
The Music Lesson (detail, see p.41)

TOP RIGHT:
Woman and Two Men (detail, see p.33)
Important leitmotif
White porcelain jugs appear repeatedly in Vermeer's art. They contained wine, which was supposed to act as a love potion and help men seduce women.

has something to do with an extramarital love affair. The man in the neighbouring room, who was later painted out, is not the only indication of this. The picture that is hanging on the wall over the woman is not a coincidence: it is a *clavis interpretandi*, giving us a clue as to the erotic context of the scene. It is difficult to make out, as it is in strong shadow. It has been possible to ascertain that Vermeer is making a reference here to one of Cesar van Everdingen's paintings, which depicts a putto, or small Eros, wearing a mask, which was a sign of pretence. Everdingen's picture goes back to an emblem of Otto van Veen's (*Amorum Emblemata*, Antwerp 1608), whose motto was "Love demands honesty".

Other items which indicate the erotic content of Vermeer's picture include the almost still-life bowl of fruit – the "fruits of evil" – and the egg, wrapped up in a cloth, which is a sign of something that should be avoided: unbridled libido. Vermeer must have known parts of classical literature which were frequently quoted by seventeenth-century authors, such as Jacob Cats, who were keen to educate the people. According to them, women were forbidden to drink wine, as drunkenness led to whoring. One classical saying was repeatedly cited: *Mulier si temetum biberit domi ut adulteram puniunta* (If a woman drinks wine at home, she should be punished as an adulteress).

Vermeer was starting to place great emphasis on geometric compositions when he painted this picture. Something appears here which was to become typical of most of his interiors: rooms which are arranged parallel to the picture, something which can be seen by the back walls, and also by the tables placed, like barriers, horizontally to the frame. This enabled him to avoid the strong distortions of perspective caused by using a *camera obscura* (cf. p.18). The effect which this in turn caused was a strong tendency to align the surfaces in the room so that doorframes, mirrors and pictures, tables and other furnishings take on an almost abstract tectonic and geometric structure.

Girl Asleep at a Table (detail, see p.26)

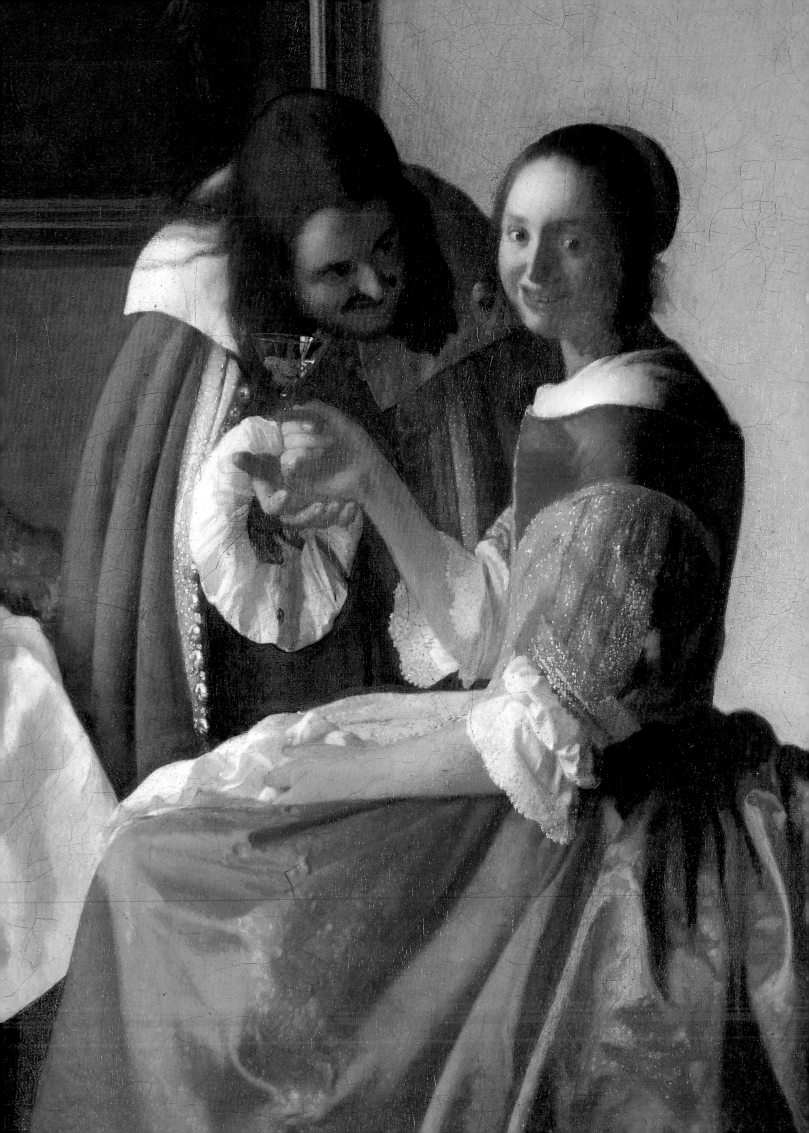

The Temptations of Love

Seduction and Wine

The theme of the girl asleep was taken up again by Vermeer in his painting *Soldier and a Laughing Girl* (p. 32). In the (probably) earlier painting (p. 26), the situation appears to have been freed from the narrative context; in the latter, the process of seducing someone with the help of wine is depicted quite bluntly. We see the partial profile of a soldier who is wearing a wide-brimmed hat, and is sitting, in deep shadow, in the foreground on the left, with his hand on his hip and his back partly turned to us. He is talking to a young woman who is smiling back at him; she is wearing a white headscarf and is lit up by the light streaming in through the open window. The rhetorical gesture of her open left hand underlines the nature of the conversation here. Nowhere else in Vermeer's pictures is there such a great difference between the sizes of the man and the woman; it is caused by the sharply shortened perspective of the room. The man dominates the scene; it is he who is trying to use wine to make the young woman submissive. The contrast between light and shadow could even contain unconscious (or perhaps intentional?) psychological symbolism. It is likely that the woman, who is lit up by the sun, embodies the principle of purity, and that she is, so to speak, the victim of the man's dark and sinister machinations.

Vermeer's love of maps[9] is expressed in his reproduction of one on the back wall of the room; maps, like the pictures he included, were of particular significance in his paintings. This map was designed in 1620 by Balthasar Florisz. van Berckenrode and published by Willem Jansz. Blaeu shortly afterwards. The Latin inscription reads, "NOVA ET ACCVRATA TOTIVS HOLLANDIAE WESTFRISIAEQ(VE) TOPOGRAPHIA", and shows that the map covers Holland and the West Frisian Islands; in contrast to modern cartographic practice, the map is on an east-west, not a north-south, axis. Maps were still an expensive luxury in the middle of the 17th century, but they were also considered a sign of humanistic knowledge. To refer to such maps was frequently a device on the part of Vermeer by which to allude to contemporary political situations. Thus this picture, with the soldier, could be an allusion to the Anglo-Dutch War of 1652–54, during which Admiral Michiel Adriaenszoon de Ruyter won many great victories for the Republic of the United Netherlands.

The Glass of Wine (p. 37) has a similar theme to the *Soldier and a Laughing Girl* (p. 32); it differs, however, in that it portrays its characters at a greater distance from our own point of view. They are not cut off by the lower frame of the picture, a device which would make them seem extremely close; instead, they can be seen in the centre of the room. The layout of the room in particular the chequered pattern of the tiled floor, was evidently inspired by Pieter de Hooch.

The man is offering wine to the woman – as an aphrodisiac, to lower her resistance. His hand is clutching the handle of a white carafe that appears as a significant leitmotif on several of Vermeer's paintings (cf. pp. 28–29, 33, 39, 41). Here

The Glass of Wine (detail, see p. 37)
Forbidden pleasures
Women who had become intoxicated on wine were considered to be the embodiment of sin, and this is a motif central to Vermeer's work. According to Jacob Cats, a famous popular teacher of the seventeenth century, women should be forbidden drink altogether, as alcohol was the first step towards whoring.

Woman and Two Men (detail, see p. 33)

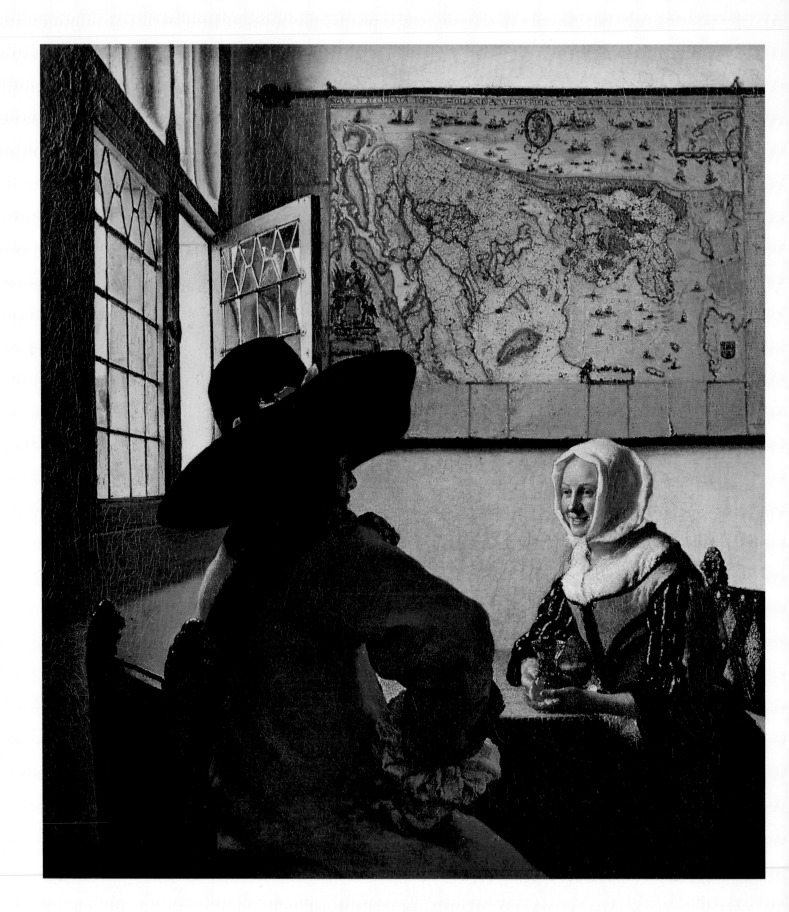

Soldier and a Laughing Girl, c. 1658
A soldier is trying to seduce a young woman by giving her wine;
he seems disproportionately large, and this is probably due to the use
of a camera obscura.

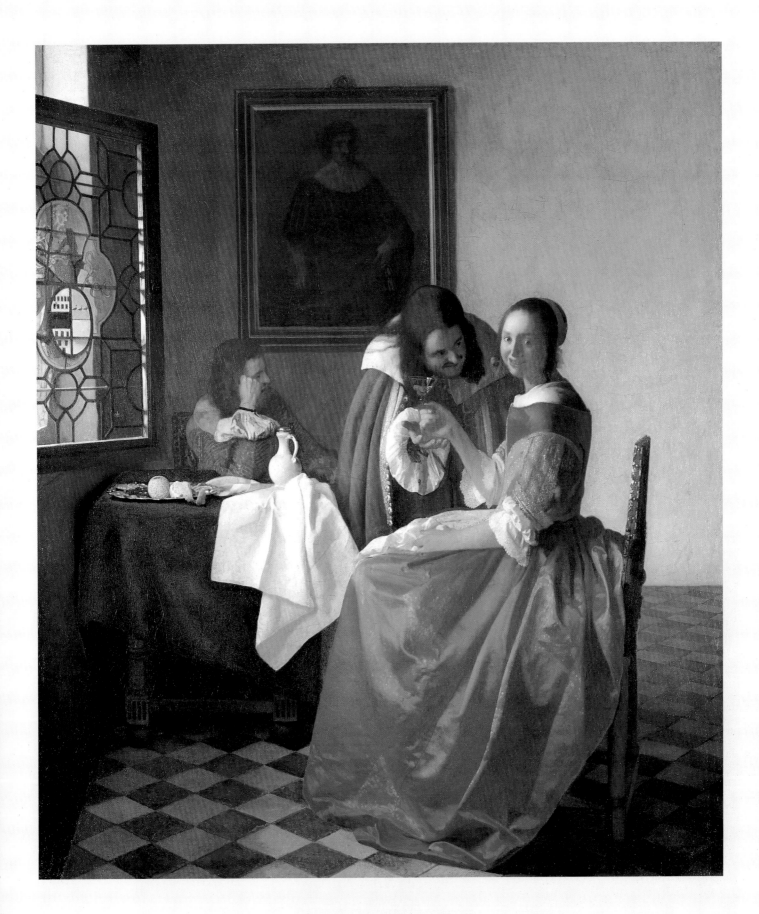

Woman and Two Men, c. 1659–60
The woman is looking towards us questioningly; the man in the centre,
who is trying to get her to drink, seems to be acting as a matchmaker
between her and the gentleman seated sideways in the background.
The portrait on the wall is probably of her husband. It is no accident that,
though he is not actually present, he should be there in this picture,
looking at the young woman.

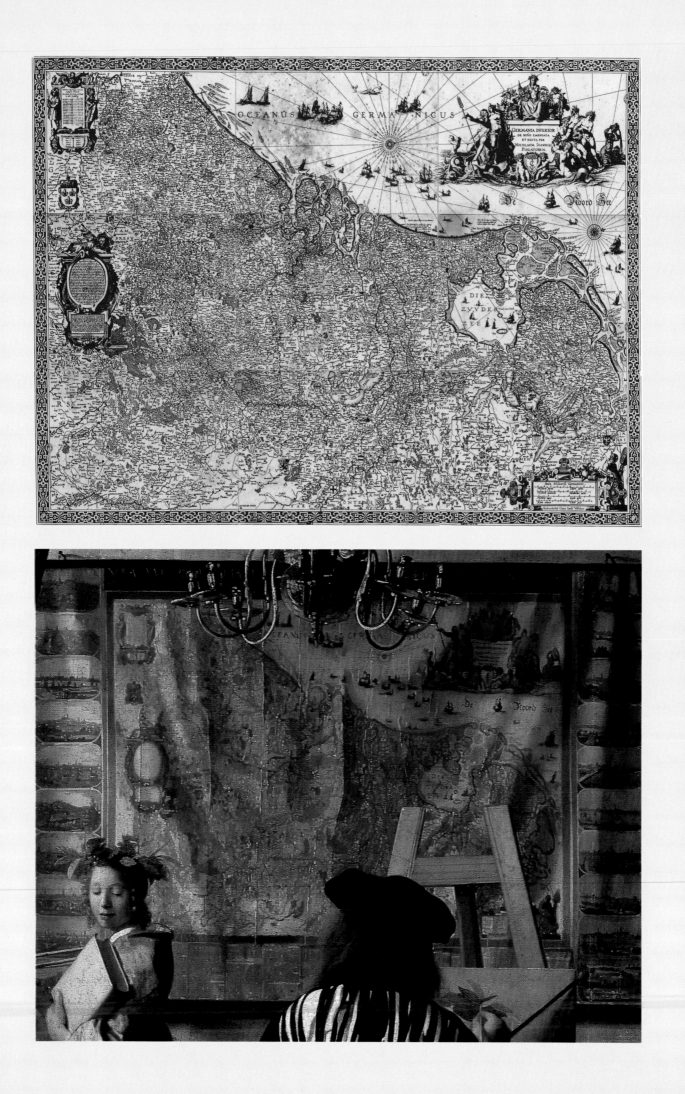

Maps of the Netherlands
Vermeer's love of maps becomes apparent in the way he decorates his
interiors. The role of maps was twofold: on the one hand, they
indicated wealth (in the seventeenth century, maps were an expensive
luxury); on the other hand, they refer to a good level of education.
Cartography was still a new science, but was beginning to be held in
high regard.

Woman and Two Men (detail, see p. 33)
A warning
The above detail in the window appears in both *The Glass of Wine* (p. 37) and *Woman and Two Men* (p. 33). It is an image of Temperance, and was intended to act as a warning to the people in the painting.

Gabriel Rollenhagen:
Illustration of Temperance in *Nucleus Emblematum*, 1611
The inscription on the emblem is "serva modum" (Be moderate). The Level (symbolising good deeds) and the Bridle (symbolising emotional control) are attributes that often accompanied personifications of Temperance.

it is placed squarely in the middle of the picture, and cannot be overlooked. The man is appraising the young woman with his gaze, and she has already raised the shimmering glass to her mouth; it half covers her face, almost like a mask.

The scene has evidently been preceded by a musical divertimento to get them into the right mood. This is suggested by the lute which has been placed on the chair, and the sheet music lying on the Persian carpet on the table.

This room makes a gloomier impression, in contrast to the one the *Soldier and a Laughing Girl* are in. The reason for this is that the lower part of the window in the background is shuttered, and a curtain is drawn across the upper part. As in the case of the *Woman Weighing Pearls* (p. 59), this is not without its deeper significance. It is probably a reference to a Biblical passage, Proverbs 4,19: "The way of the wicked is as dark as night". So something is occurring here that has good cause to shun the light. A German encyclopaedia, Zedler's *Universal-Lexikon* (Halle/Leipzig, 1734, vol. 8, col. 339), associates dark rooms with adultery, and quotes Job 24,15: "Others of them hate the light", "The eye of the adulterer watches for twilight, 'No-one will see me,' he mutters."

The partly opened window has a particular moral meaning which acts as a commentary on the scene, as it were. On it there can be seen – next to the arms of Jannetje Vogel, who died in 1621 and whose first marriage was to Vermeer's neighbour Moses J. Nederveen[10] – a symbolic motif which has its origins in an illustration in Gabriel Rollenhagen's 1611 Book of Emblems (p. 36). It concerns the personification of *Temperantia*, or Temperance, one of the cardinal virtues, together with its attributes, the Level (symbolising good deeds) and the Bridle (symbolising emotional control). The window is directly in the woman's line of vision, and is her opposite, its purpose being to serve as a warning.

The theme of Temperance crops up again in Vermeer's Brunswick painting *Woman and Two Men* (p. 33), and the purpose of this picture is clearly similar. The scene does differ from the Berlin picture *The Glass of Wine*, however, in that not one but two men are present. The seduction seems to be even more intensive, and the man in the centre is bending down and talking to the young woman; she is wearing an elegant, full satin dress and looks rather embarrassed and unsure of herself. While the young woman in the Berlin painting has already raised her glass to her mouth, her counterpart in the Brunswick painting still seems somewhat reticent and uncertain.

The drink need not necessarily have been wine. It could also be a love potion (Lat. *poculum amatorium*, Fr. *philtre d'amour*), such as is frequently mentioned in seventeenth-century medical writings; Jan Baptista van Helmont said that it caused "the natural essences of life to surge".[11]

The effect could be one of two things: either excessive, foolish love, or a paralysing melancholy. The man seated at the table, leaning his head on his hand, has evidently also drunk some, because his attitude is one of melancholy. It is likely that the man in the centre is acting as a matchmaker, and that in the absence of the husband (because on the wall is the portrait of a man, and it is no coincidence that he is looking down at the woman). What is taking place here is the initiation of a secret love affair, *clam et absente marito*, or secretly and in the absence of the husband, as it was phrased in legal texts of the time that dealt with adultery.

A peeled lemon in *Woman and two Men* lies on a silver dish next to a jug which has been placed on a white cloth in an arrangement which is almost like a still life; the purpose of the lemon was to reduce the effect of love potions.

The Power of Music
The Berlin painting *The Glass of Wine* (p. 37) has already tied in the motif of love potions with that of music; this combination appears even more forcefully in *Girl Interrupted at Her Music* (p. 39). A young woman wearing a red jacket

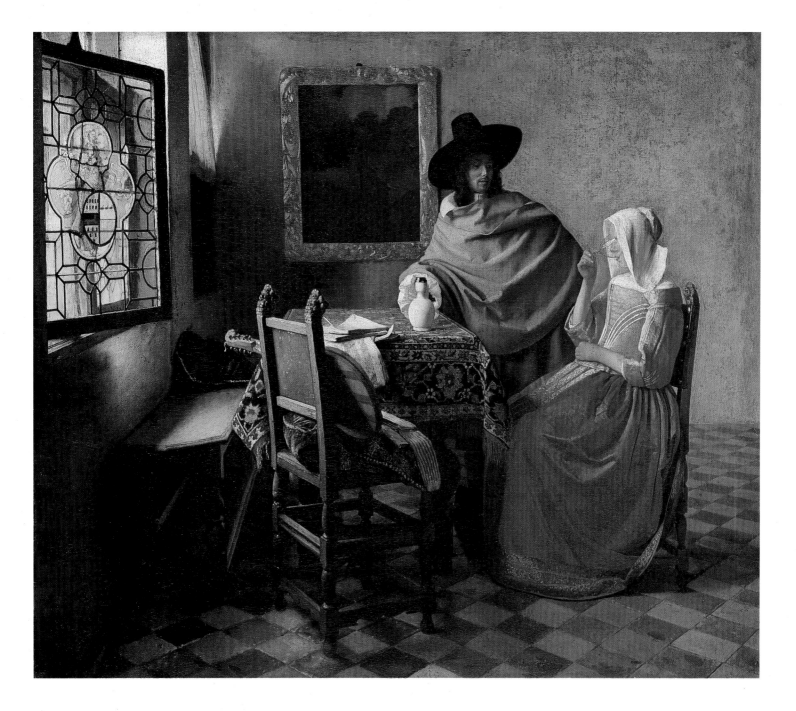

and white headcloth has just laid her lute and sheet music down on the table, in order to start reading a letter which a man has just given to her. She gazes towards us questioningly, uncertain whether she should read this secret message – it is probably a love letter. Once again the theme of the painting is erotic, as is suggested by the barely recognisable scene in the faded picture on the back wall, which is based on a painting by Cesar van Everdingen. It features Cupid, who is holding up a love letter. This picture within a picture also appears in another of Vermeer's paintings, *Lady Standing at a Virginal* (now in London; cf. p.38). Everdingen's painting derives from an emblem by Otto van Veen (*Amorum Emblemata,* Antwerp 1608), which bore the motto "*perfectus amor est nisi ad unum*" (There can only be perfect love for one person). So the young woman shown here is in the process, against the expectations of society, of being unfaithful to her husband. The birdcage on the wall is a sign of how she should be behaving; in books of emblems, such as that of Daniel Heinsius (*Emblemata amatoria*, Leiden 1615), a birdcage symbolised the willing captivity of love. Heinsius' motto ran: "For I have bound myself" (*Perch' io stesso mi strinsi*).[12]

The Glass of Wine, c. 1658–60
Like *Woman and Two Men* (p.33), this seduction scene contains an open window which features the warning figure of Temperance.

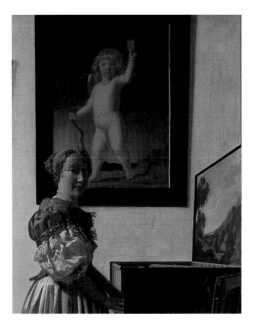

Lady Standing at a Virginal (detail, see p. 42)
Painting within a painting
Vermeer repeatedly gives us hints as to how we should interpret his paintings. For instance, the cupid holding the playing card in this painting within a painting raises doubts as to the virginity of the woman at the virginal.

Otto van Veen:
Illustration of Cupid in *Amorum Emblemata*, 1608
The motto on the emblem is: "There can only be perfect love for one person."

The connection of love and music was also a central theme in the London painting *The Music Lesson* (p. 41). The overall impression here, however, is much more restrained and refined. The scene is set inside an upper middle class home. It is not seen close by, but is taking place further away from the observer, in the background by the rear wall of the room. A young woman wearing a vermilion skirt with a white blouse and black outer garment is standing there, playing on the narrow keyboard of a virginal. She is seen from behind, and is therefore anonymous, but her face can be seen in the mirror hanging over the virginal. Though the view from behind might lead one to expect otherwise, she is looking to one side, towards a young man. He is wearing an elegant black robe with a white lace collar and white cuffs, and a rapier is fastened to his sash, a sure sign of social importance.

X-ray examinations have shown that Vermeer originally painted the woman's head turned further towards the man. This shows that Vermeer was attempting to create a more balanced picture by removing the more obvious references to the theme, and that he carried out further corrections in order to broaden the significance of the scene. In this way the visual attraction of the painting becomes all the more intense. This is true not only of the muted colour harmonies, but also – indeed, all the more so – of the geometrical structures, which are of crucial importance for the composition. As in so many of his works, Vermeer heavily accentuates horizontals parallel to the picture frame – such as the beams of the ceiling, the oblongs of the virginal, the mirror, the picture on the right, and the table which, interposed like a barrier between ourselves and the subject on the right, has a heavy Persian carpet draped across it and reaching to the floor, on top of which is the familiar white carafe standing on the equally familiar silver plate. The diamond-shaped pattern of the floor tiles, which comprises white tiles set in a lattice of black ones, also pays homage to geometry.

To just what extent Vermeer was intentionally using geometric shapes in his compositions – and some scholars see pre-Mondrianesque trends in pictures such as this – will remain open to debate. It is striking, though, that after the middle of the 17th century geometry gained importance in philosophical and scientific circles. One need only think of the subtitle of Spinoza's *Ethics*: "ordine geometrico demonstrata" (arrange according to geometric principles). At that time, which witnessed the growth of the exact sciences, the ideal of geometry stood for clarity and demonstrability, and for methodical stringency in proof. Its history stretched back to antiquity, to such early masters as Pythagoras, when geometry and music were seen as close kin, both touching upon cosmic laws.

Vermeer's virginal, and the cello laid at an angle on the floor, may therefore embody an allusion to the harmony or music of the spheres. But music was also thought to possess therapeutic value, as the inscription on the virginal makes plain: MVSICA LAETITIAE COMES MEDICINA DOLORVM (music is the companion of joy and a medicine for suffering). This statement could be traced back to Pythagoras, who reputedly said that the harmonies of music could moderate and pacify agitations of spirit, and influence the emotions.

The Concert (p. 40), now in the Isabella Stewart Gardner Museum in Boston, distances what is taking place from us by moving the action to the rear wall of the room. Two pictures are hanging on it; one is a pastoral landscape, the other is the painting of *The Procuress*, by the Utrecht Caravaggist Dirck van Baburen (cf. p. 24), which Vermeer often includes in his own paintings. A harpsichord is positioned close to the wall, and we see a young woman in profile playing it. She is accompanied by a man playing a lute (only the end of the fingerboard with the tuning keys is visible); his back is turned towards us, and he is sitting beside the harpsichord facing the Arcadian landscape on the lid of the instru-

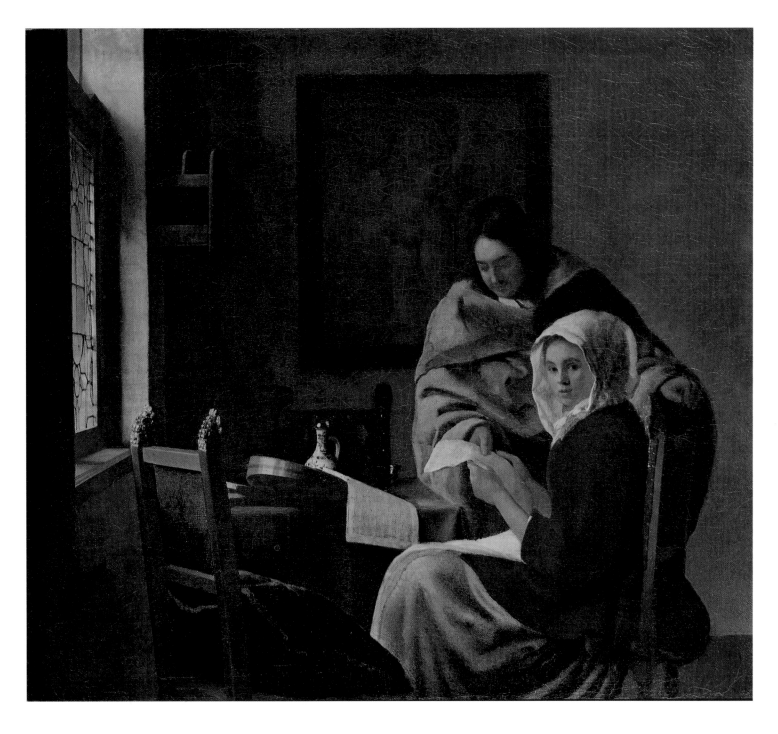

Girl Interrupted at Her Music, c. 1660–61

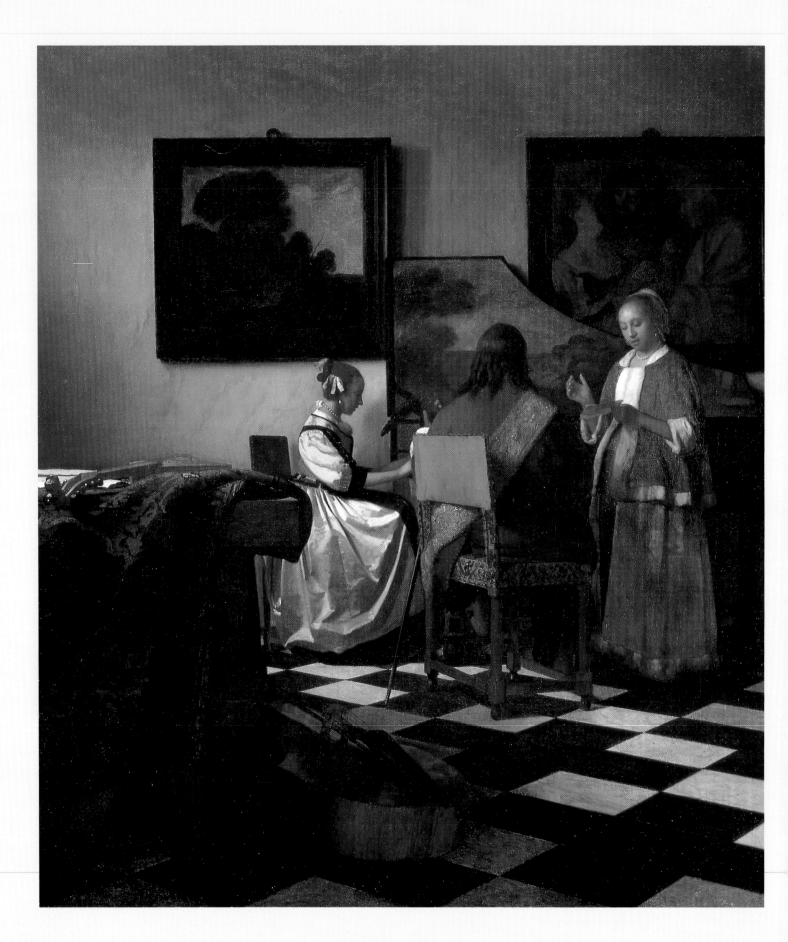

The Concert, c. 1665–66
The erotic nature of this scene is indicated by the pastoral landscapes on
the wall and the lid of the virginal, and also by the inclusion of
Dirck van Baburen's *The Procuress*.

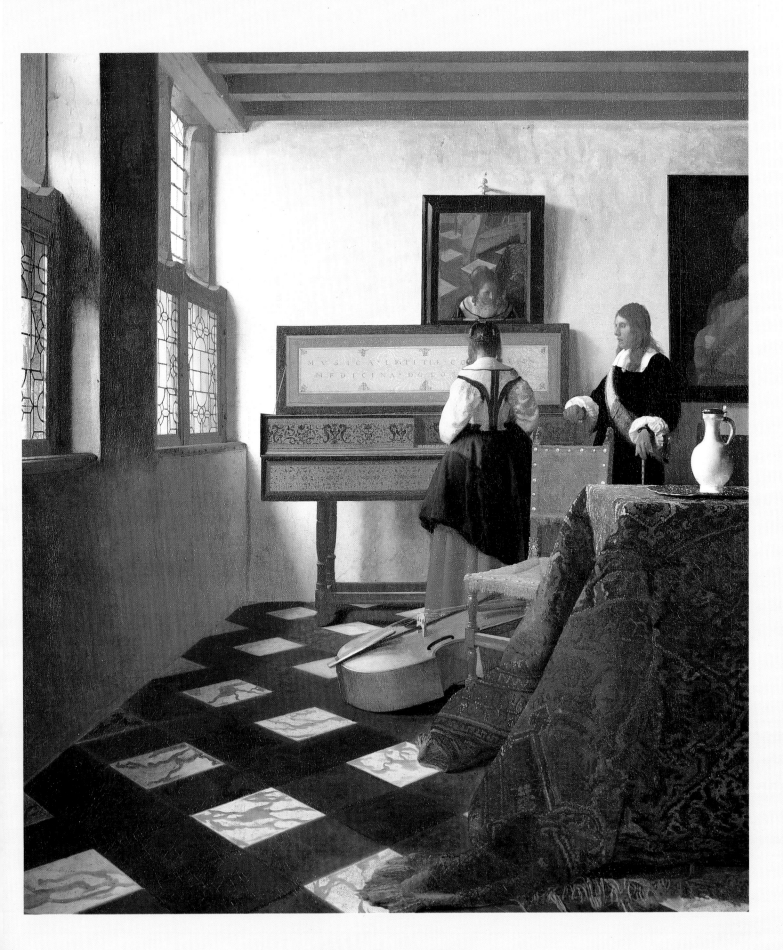

The Music Lesson, c. 1662–65
The inscription on the lid of the virginal reads: Musica Laetitiae
Comes Medicina Dolorum (music is the companion of joy and
a medicine for suffering).

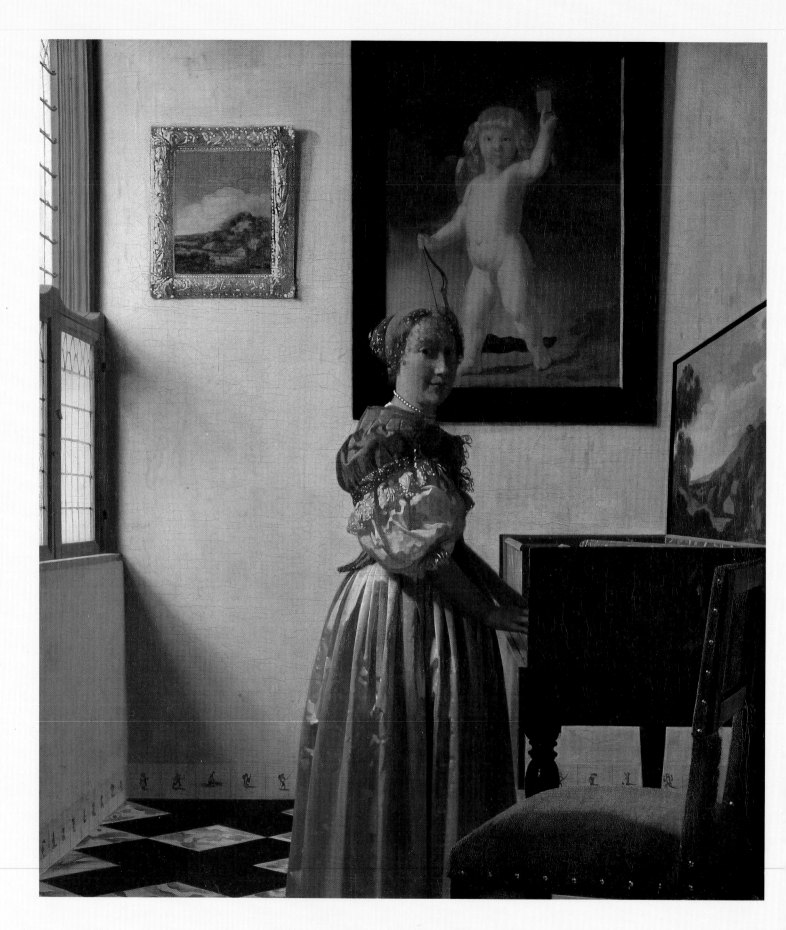

Lady Standing at a Virginal, c. 1673–75
The name of the instrument she is playing is an allusion to this woman's
virginity. In the seventeenth century, great care was taken in the Netherlands
that a woman entered marriage intact. The cupid in the background
seems to be poking fun at this morality.

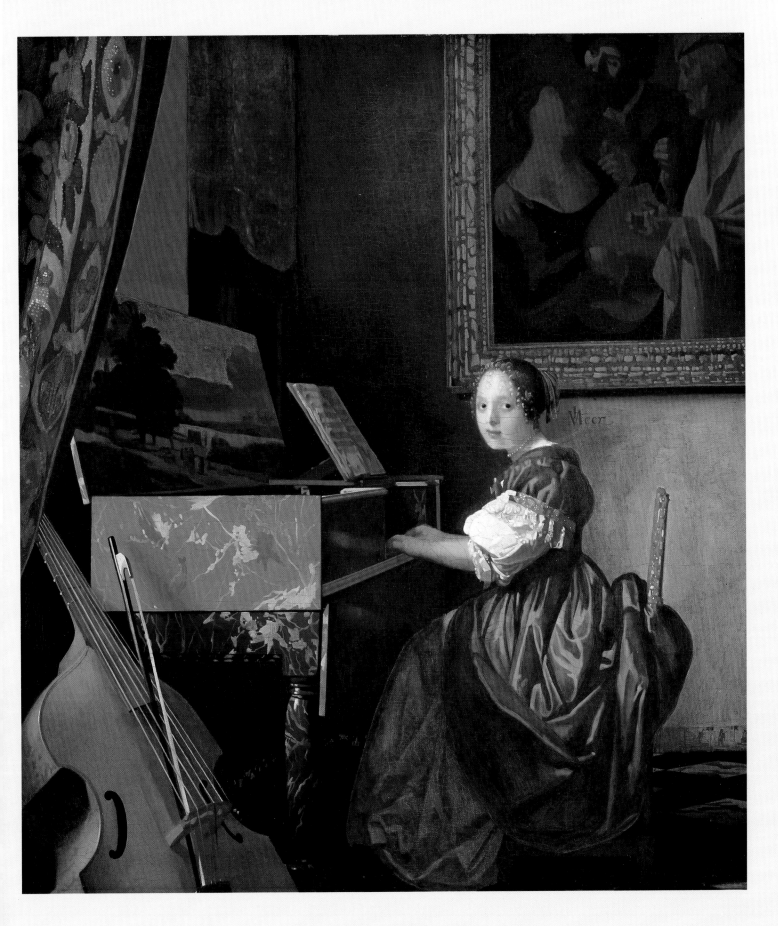

Lady Seated at a Virginal, c. 1673–75
The cello leant against the virginal suggests that someone else has been
in the room until quite recently.

ment, on a chair which is placed at an angle to the room. A somewhat older woman, who is singing the vocal accompaniment, is standing next to them. Further musical instruments, grouped like a still life, are on the floor and the sturdy oak table on the left. Vermeer particularly liked stringed instruments (the harpsichord may be included in the family), and they belonged to a long tradition of musical symbols of proportion and harmony.

In classical times, the cithara was a stringed instrument that was held in high regard. It was considered noble enough to be dedicated to Apollo, and this is in sharp contrast to the flute (*aulos*), which was dedicated to Dionysus and, due to its association with orgies, was considered to be a most primitive instrument. Such musical concepts, which had been passed on by humanistic traditions, were still current in the seventeenth century. Nor should we forget the theory of emotions prompted by music; this had a long tradition and was summarised by Jan Tinctoris (1435/36–1511). This theory held that the task of music was not only to praise God, but also to dispel melancholy, to exalt the spirits on this earth, to heal the sick, to entice love, and to make life together more pleasant.[13] These last two aspects, in particular, were those that Vermeer and other Dutch genre painters (such as Gerard Terborch) were alluding to in their house-music scenes.

As well as duets and trios, Vermeer frequently painted solo performers, without exception women. *Lady Standing at a Virginal* (p. 42), which Bürger-Thoré bought, can be dated to his late phase (approximately 1673–75). We see a relatively small spatial area. Once again, there are two paintings hanging on the wall, one a small gold-framed landscape (perhaps by Allaert van Everdingen or Jan Wijnants), the other Cesar van Everdingen's Cupid, which we have already seen as a *clavis interpretandi* in *Girl Interrupted at Her Music* (p. 39). Cupid is holding up a card, a gesture which plainly relates to the young, seemingly naive woman. Structurally, this feature recalls the smirking figures in Dutch genre paintings, whose victims do not notice what is going on since the gestures are made purely to assist our understanding. These gestures derived from performances of comedies and farces, where pointed remarks and innuendoes addressed to the audience, outside the frame of the action, were the order of the day. We have already seen that Vermeer is using Everdingen's picture as a means of referring to Otto van Veen's emblem (p. 38) granting perfect love for one person only – the husband, of course. The instrument the woman is playing, a virginal, suggests through its name her virgin status – though Cupid may be ironically questioning it.

The subject of virginity preoccupied the authors of didactic and legal tracts at that period. In a society whose patriarchal structures were being consolidated, there was much eager debate of whether women should enter marriage intact. Alongside this debate on social norms, however, there was always the realisation that unbending moral precepts had but little connection with the real world. Dutch genre painters, who took the authority of Cicero in conceiving of their pictures as visual comedies, were notably sceptical, portraying the prevailing morality in their paintings while simultaneously subverting it with irony.

Vermeer's second picture of a woman at a virginal (p. 43), which critics assign to his final period, is similar in its deployment of motifs to the *Lady Standing at a Virginal* (p. 42). The girl is seated at the virginal, gazing sideways at us. Her head and arms have not been painted with great attention to individuality, and even the folds of her clothing are only slightly nuanced areas of colour with a few unsubtle highlights. The cello in the foreground, leant against the marble-patterned virginal, suggests that a second person has just been present, that their duet may, in other words, have included a little flirtation. Dirck van Baburen's *Procuress*, the painting on the wall, underlines this innuendo. Blue curtains have

Crispin de Passe:
Amor Docet Musicam
Etching for Gabriel Rollenhagen's *Nucleus Emblematum*, Cologne 1611. Amor was traditionally depicted holding a lute.

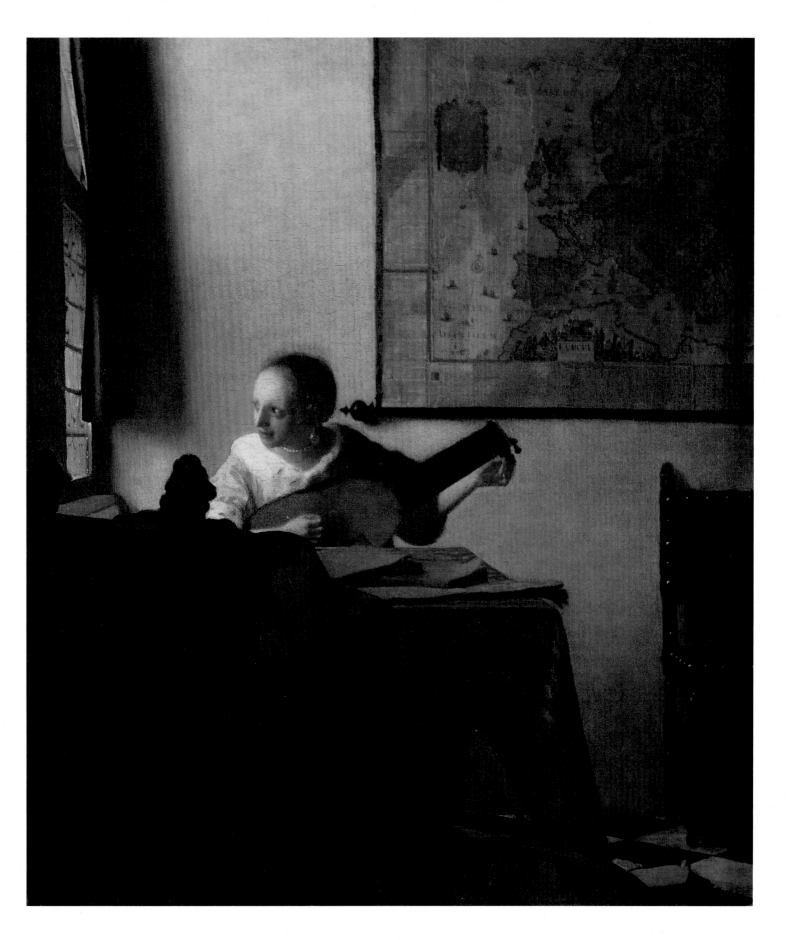

Woman Playing a Lute near a Window, c. 1664
The pearl earring and necklace came to light when the painting was
cleaned in 1944. They gleam prettily in the light.

Anonymous:
Copy of *The Guitar Player*, c. 1700

been drawn across the window, darkening the room and implying that this secret rendezvous does not welcome the light of day.

The window in *Woman Playing a Lute near a Window* (p. 45) has also been shaded. Light enters only at the bottom, below the curtain, brightening the yellow of the young woman's right sleeve and part of her collar. Her forehead, too, is lit by this indirect light. Her pearl earring (revealed in 1944, when the painting was cleaned) and her pearl necklace are gleaming.

The girl is sitting behind a table, in front of which stands a chair in dark silhouette. She seems to be tuning her instrument, and is leaning forward a little, her head inclined to listen. Since the Renaissance, the lute had been the attribute or sign of music *par excellence* in symbolic works; at times it also represented one of the five senses, hearing. A quiet instrument, it was most suitable for indoor playing, and hardly at all for concerts in the open.[14] It was primarily an instrument for private solo performance, and thus had a certain intimacy.

The same was true of the guitar, the main subject in a late Vermeer, *The Guitar Player* (p. 47). Again, the room has been somewhat darkened. In the corner, books are piled on a table, while in the foreground a young woman is playing the guitar. This *divertimento* is doubtless being played to encourage thoughts and feelings of love. These feelings are at odds with the reading of books, which lie neglected; it is impossible to be certain what books they are, but it is a fair guess that the Bible and Catechism are among them, since these were recommended to young ladies for moral guidance. Vermeer painted one more picture of a girl alone with her instrument, *Girl with a Flute* (p. 71). In her left hand she is holding a flute, an instrument traditionally with erotic associations. In the story of Hercules at the parting of the ways (Xenophon: *Memorabilia* 2, 1–22) – which was repeatedly painted by Renaissance artists, since it dealt with the polarity of virtue and vice – the flute was a symbol of sensuality. As we have already seen, it was used in the cult of Dionysus or Bacchus, the God of Wine and of unrestrained libido.

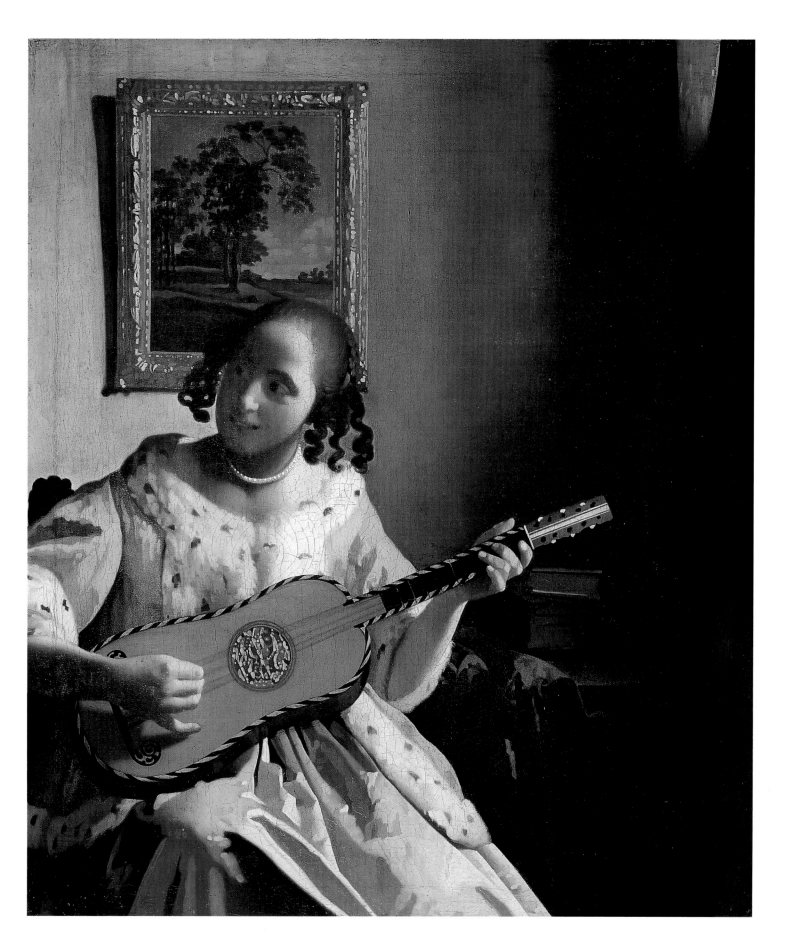

The Guitar Player, c. 1672
The pastoral landscape in the background and the guitar are both signs
of love. But this is no Arcadia. Love has to hide away in the
secrecy of a darkened room.

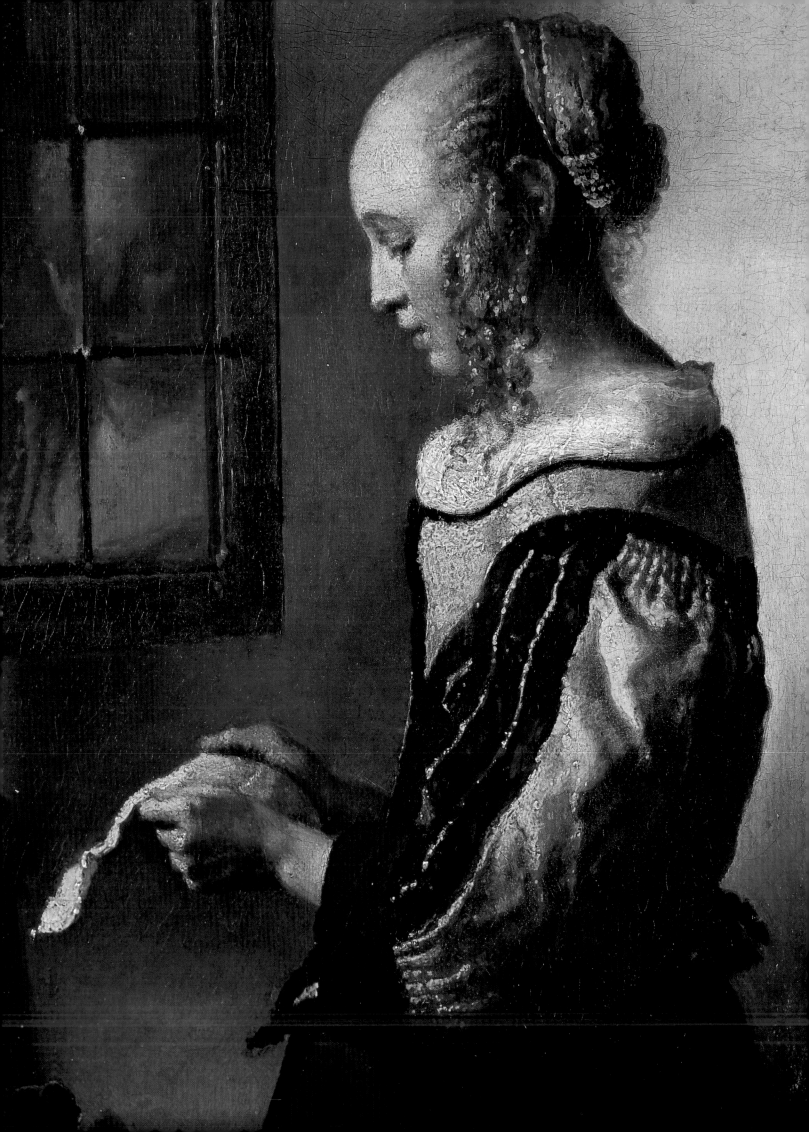

Secret Yearnings

Love Letters

Vermeer's *Girl Reading a Letter at an Open Window* (p. 50), now in Dresden, is usually considered to be an early work. It shows a young woman at an open window, reading with great inner tension and attentiveness a love letter that has been addressed to her. We see her in profile, but her face is reflected at a slight angle in the lightly coloured, uneven glass panes of the leaded window (the same feature occurs in the picture *Soldier and a Laughing Girl*, cf. p. 32). The fact that it is open does of course superficially serve to increase the amount of light falling into the rather dark room, but in another sense it represents the woman's longing to extend her domestic sphere, and her desire for contact with the outside world, from which she, as a housewife forced to keep to her society's norms, is largely isolated. This longing to break free from isolation is occasionally also a feature of Pieter de Hooch's paintings, such as the one which features a woman standing in an entryway and looking out onto the street. The bowl of fruit in Vermeer's *Girl Reading a Letter at an Open Window*, which is lying on the folds of the table rug, is a symbol of extramarital relations, which broke the vow of chastity. Such a relationship is being planned or continued by means of this letter, and the apples and peaches (*malum persicum*) are intended to remind us of Eve's transgression. The yellowish-green silk curtain and rail is an artistic piece of bravura on the part of Vermeer. It is difficult to decide whether it is to be seen as part of the picture, a curtain in the room, like others that Vermeer uses, pushed to one side to reveal what is going on, or whether – as in Rembrandt's 1646 picture of the Holy Family, now in Kassel – it is meant to create the illusion of a protective curtain hung in front of the painting.

Another woman who is lost in thought, completely engrossed in reading the letter she has just received, is the *Woman in Blue Reading a Letter* (p. 51). Like the girl in the Dresden painting, she is facing the window, which is not visible, though the brightness of the wall on the left would suggest the presence of such a source of light. The woman may well be pregnant.[15] If that is indeed the case, her reading of this letter would be a moral contradiction of the respectability of marriage, which, according to contemporary writings on marriage, was an institution that was designed to ensure the reproduction of the species and did not allow for "unchaste, lascivious thoughts".

Speculation in earlier works on Vermeer that the woman depicted here could well be his wife, who went through a large number of pregnancies, is immaterial when we interpret this painting. Even if Catharina Bolnes was the artist's model, the painting should not be viewed as a biographical document; what is being portrayed and discussed here is a more general social problem. As in the painting of the *Woman Weighing Pearls* (p. 59), or the *Woman with a Pearl Necklace* (p. 57), the box of pearls is a symbol of Superbia, or vanity, because this woman is dressing up for her lover.

Girl Reading a Letter at an Open Window
(detail, see p. 50, left)
The Fall of Eve
The letter is the start of a secret love affair.
Apples and peaches remind us of Eve's Fall.

Girl Reading a Letter at an Open Window
(detail, see p. 50, left)
Yearning for the outside world
Open windows frequently have a figurative meaning in Vermeer's paintings. Taken together with the letter, which the girl is holding, this motif represents the desire to break free from the restrictions of the home and make contact with the outside world.

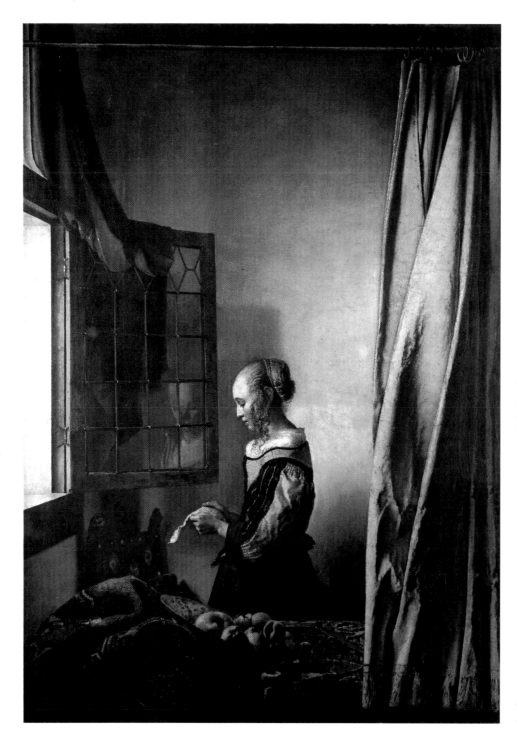

X-ray of *Girl Reading a Letter at an Open Window*
This x-ray shows that Vermeer originally intended to incorporate a Cupid in this scene; that would indicate that the girl is reading a love letter.

Girl Reading a Letter at an Open Window, c. 1657

The woman wearing the yellow, ermine-trimmed jacket (p.52), who is herself writing a love letter with a goose quill as she smiles at the observer, is also smartly dressed up. A pearl necklace with a yellow ribbon is lying right next to the letter paper, and it is also possible to make out a jewellery box and an ink set. In contrast to the Amsterdam picture, which presents the theme of vanity rather discreetly, the theme is quite unmistakable here. The inclusion of the decorative ribbons and pearl earrings is intended to show the woman's craving to be smart and be admired (cf. p.58) – though pearls can also have a more positive meaning in Vermeer's art (cf. p.59). For the artist, they were a welcome opportunity to show off his talents in creating the gradations of yellow, which are continued in darker tones in the jacket. According to Andrea Alciatis' *Emblemata* (Lyons 1550, p.128), yellow is a colour which is *amantibus et scortis aptus*, or "appropriate for lovers and whores".[16]

The woman's fashionable appearance and the objects on the table are repeated in Vermeer's *Lady with Her Maidservant* (p.53). A new feature in this scene is the maid, who is stepping forward out of the dark background to give the woman a letter; the latter, who has just written a few lines, is obviously hesitant to accept it. It seems to throw her into confusion, and she is beginning to have scruples about whether she should let herself in on this adventure or not. It may be that what she is writing in her own letter, and the content of the message that she has yet to read, are at odds. The maid's expression makes it obvious that she is in on this secret affair. She is acting as a silent go-between, and enjoys the confidence of her mistress.

The relationship between the mistress and maid in *Lady Writing a Letter with Her Maid* (p.55) is of a similar nature. The scene is different in that both characters are turned fully towards the observer; the maid is standing with her arms folded, waiting for the letter which the woman, dressed in a white blouse and white cap decorated with pearls, is writing eagerly. A seal, which has fallen off the table, is lying at the front on the floor. The maid is looking at the window, which features the only just recognisable Allegory of Temperance familiar from other paintings by Vermeer (cf. p.36). It serves as a warning to the woman to act moder-

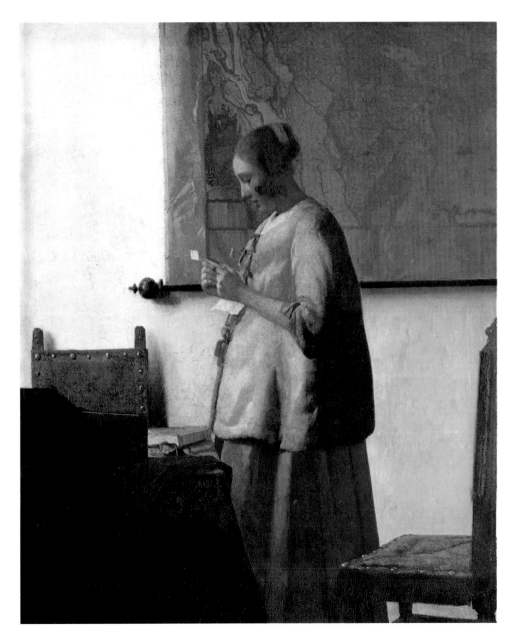

Woman in Blue Reading a Letter, c. 1662–64

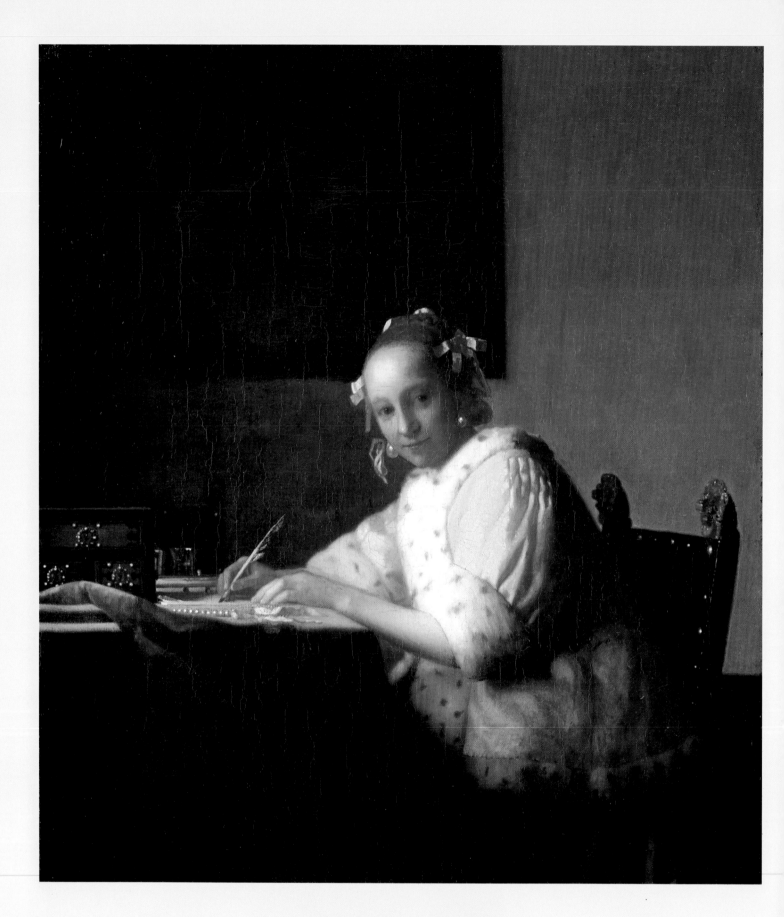

Lady Writing a Letter, c. 1665–70
This young woman has paused in the act of writing and is looking at us;
she is dressed fashionably, and is wearing ribbons in
her hair and pearls.

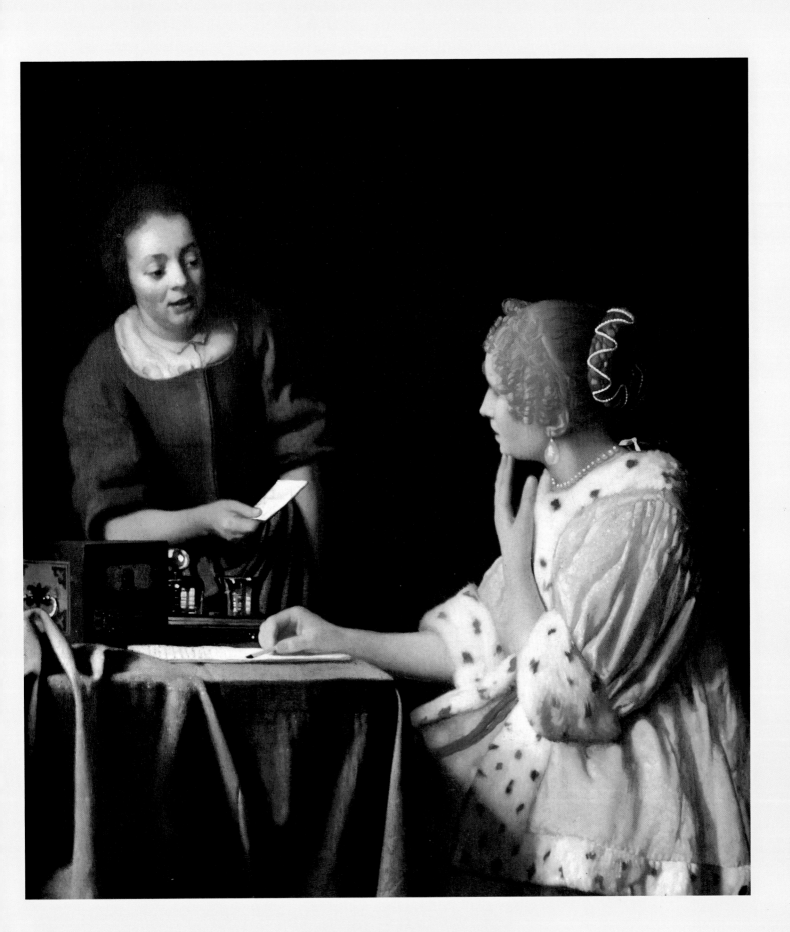

Lady with Her Maidservant, c. 1667–68
A new element here is the maid, stepping out of the darkness to hand
a letter to her mistress, who has just been writing a few lines. She is
evidently being handed a love-letter secretly.

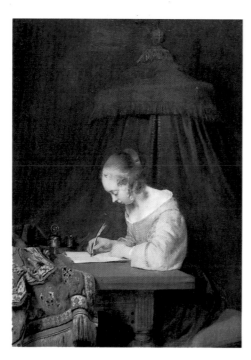

Gerard Terborch:
Woman Writing a Letter (detail), c. 1655

ately and keep her emotions under control. The picture on the wall shows the finding of the infant Moses, who had been set adrift on the Nile (Exodus 2, 1–10). This picture also appears, smaller, in *The Astronomer* (p.76), now in Paris. It is a reference to secret love affairs. In the 17th century, the story of Moses probably reminded people of child abandonment. As Pierre Chaunu and Pierre Goubert have shown, this was a common practice amongst women who, in the face of draconian punishments, had to cover up the existence of illegitimate "children of sin".[17] This is confirmed, for instance, by the *Recherches statistiques sur la ville de Paris*, carried out after 1680. It was a period that saw the norms of marriage becoming more rigid, the demands of monogamy more imperative; and to suit the instincts and native sensuality of the individual to the behaviour expected of him or her was a task scarcely to be accomplished. The very high number of paintings that deal with extramarital relations show that it was difficult to impose proper monogamous behaviour from above.

Though the love-letter motif may at first glance appear an innocuous, anecdotal thing, then, it was in fact anything but. The contemporary literature of jurisprudence declared that *litterae amatoriae* (on which dissertations were written) were a proper subject of legal enquiry. The lawyers would aim to determine whether such letters implied a promise of marriage or (if one correspondent was already married) adultery. The level of educated literacy was rising among the

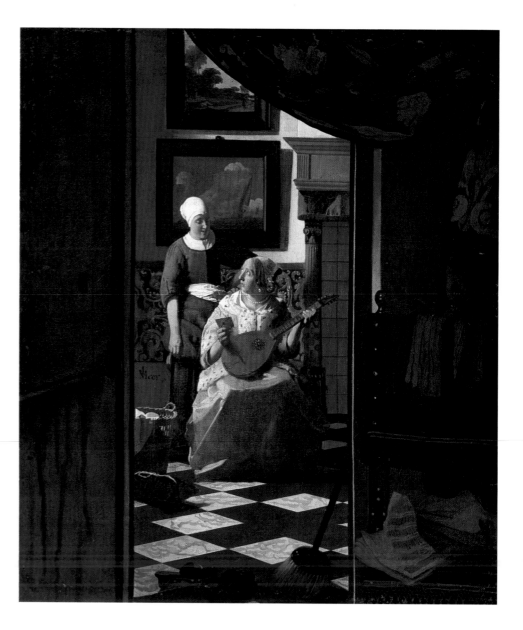

The Love-Letter, c. 1669–70

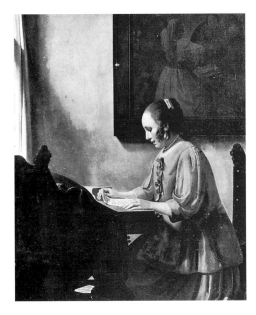

A case of forgery
The Dutch painter Han van Meegeren (1889–1947) forged this *Woman Reading a Letter*, a painting which until recently was thought to be by Vermeer. In 1937, the Boymans-van Beuningen Museum in Rotterdam paid him 550.000 guilders for a painting ascribed by Abraham Bredius to Vermeer.

Lady Writing a Letter with Her Maid, c. 1670
The maid has a special function in several of Vermeer's paintings. She is able to act as a secret messenger for her mistress, who is not able to leave the house, which has been entrusted to her care, alone. In seventeenth-century treatises, sending love-letters was considered a sign that the woman had committed adultery.

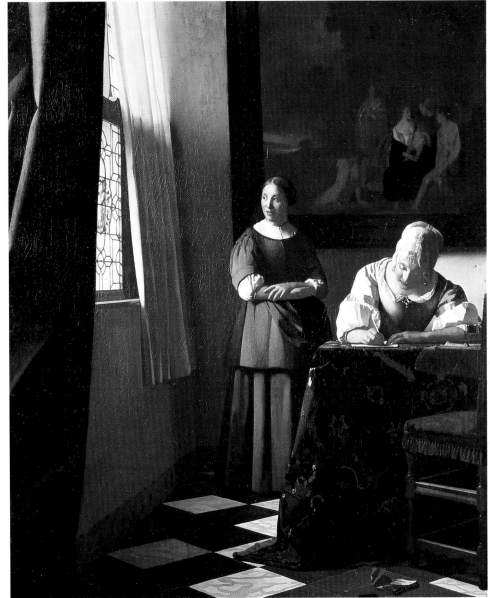

prosperous bourgeoisie, and with it exchanges of letters; and many women were able to commit their feelings to paper. From a legal point of view, of course, this represented a serious risk, since written documents could be used as evidence.[18]

Vermeer returned again to the love-letter theme in the small-format Amsterdam painting *The Love-Letter* (p.54). Again, the maid is the intimate confidante of the lady of the house. We see them from a dark hallway in which a map can dimly be made out on the wall, while on the right a musical score has been left on a chair beneath a curtain. The lady of the house is seated by a fireplace in a living room, gazing questioningly at her maid, who has just delivered a letter. The mandolin she is holding in her lap suggests that the lady has been tuning in musically to thoughts of love (cf. Crispin de Passe's emblem *Amor Docet Musicam*, p.44). In Dutch genre painting, fireplaces often stood metaphorically for the fiery passion of love. The marine painting on the wall behind her, showing a rough sea, suggests that the lady's passions have been agitated. The laundry basket, the embroidery cushion on the floor, and the broom by the door all betoken domestic duties neglected by the lady.

Pearl Jewellery

Woman with a Pearl Necklace (p.57) returns to the conflict of virtue and vice, but here the moral address is so discreet and muted that we scarcely feel it to be intended at all. A young (and perhaps pregnant) woman, wearing an ermine-trimmed yellow jacket, is seen in profile looking into a small mirror on the wall at left, which, with the yellow-curtained window, is rendered in sharp perspective. She has put on a pearl necklace, the tapes of which she is holding; and the subject of the painting is manifestly vanity, as the powder brush on the sturdy tabletop already suggests. The note lying beside the brush may well be meant to hint that she is putting on her finery for a lover.

Pearls, or pearl necklaces, carry a negative symbolic charge in the critique of *vanitas*, as we see, for example, in a thematically related illustration in Gerard de Lairesse's *Groot Schilderboek* (Amsterdam, 1707, vol I, pp. 188–193),[19] where the personification of vanity is taking a pearl necklace from a jewellery box. The main argument in favour of the vanity interpretation is the mirror, an indispensable prop in toilette scenes, such as Frans van Mieris' *Lady at a Mirror* (in Munich), in which the lady is admittedly far more magnificently dressed up than in Vermeer's work.

The motif on the leaded windows cannot be precisely made out. As in Vermeer's Brunswick picture, it may be another treatment of the subject of temperance. That is, it may represent an ethical contrast intended as a warning to a woman in danger of violating social norms: instead of leading a modest, contented and simple life, she seems to be falling prey to narcissism and the wish to be admired.

Pearls are again the subject in *Woman Weighing Pearls* (p.59). The woman is carefully holding the scales in her right hand to balance them, and resting her left on the tabletop in order to concentrate. The room has been darkened by a curtain drawn across the window at the back left, where a strip of daylight can be seen. The pale light that enters the room is diffuse; but, since the source of light is at the top left, the visual space is divided diagonally into a brighter and a more shadowy area. The shadowy area becomes quite impenetrably dark in places, especially at the front left, where we can hardly make out what the objects in the painting are. Against this gloom, the pearls taken from the boxes are a sparkling highlight.

The picture on the wall behind the woman is a Last Judgement. The apocalyptic scene is an eschatological appeal to the conscience of the woman, plainly bearing a semantic relation to her thoughts and actions. On the Day of Judgement, as Christian teaching familiarly has it, good and evil will be sundered and the Blessed separated from the Damned. Christ, in his capacity as judge, will either grant the soul eternal peace, or damn it to the everlasting torments of hell.

Since the composition of this painting is closely related to that of the Berlin *Woman with a Pearl Necklace* (p.57) – both pictures featuring a mirror on the wall and the props of vanity on the table – it is tempting to interpret the action of this woman wary of the daylight in terms of *vanitas*. However, the action of weighing is ambivalent. Indeed, we may almost feel the woman's action echoes that of the weighing of the souls of the Resurrected (Job 31, 6). The balancing of the scales may therefore be intended in a psychological or ethical sense. Either way, there is an ambiguity of feeling in the motif. It has been pointed out that the scales are empty, and that therefore the woman's decision to forego all worldly finery has already been taken.

Woman with a Pearl Necklace, c. 1664
Vermeer is portraying the sin of vanity in this picture of a woman, who is dressed in an ermine-trimmed yellow jacket and is holding the tapes of her pearl necklace apart. The painting can therefore be seen as a criticism of such conduct.

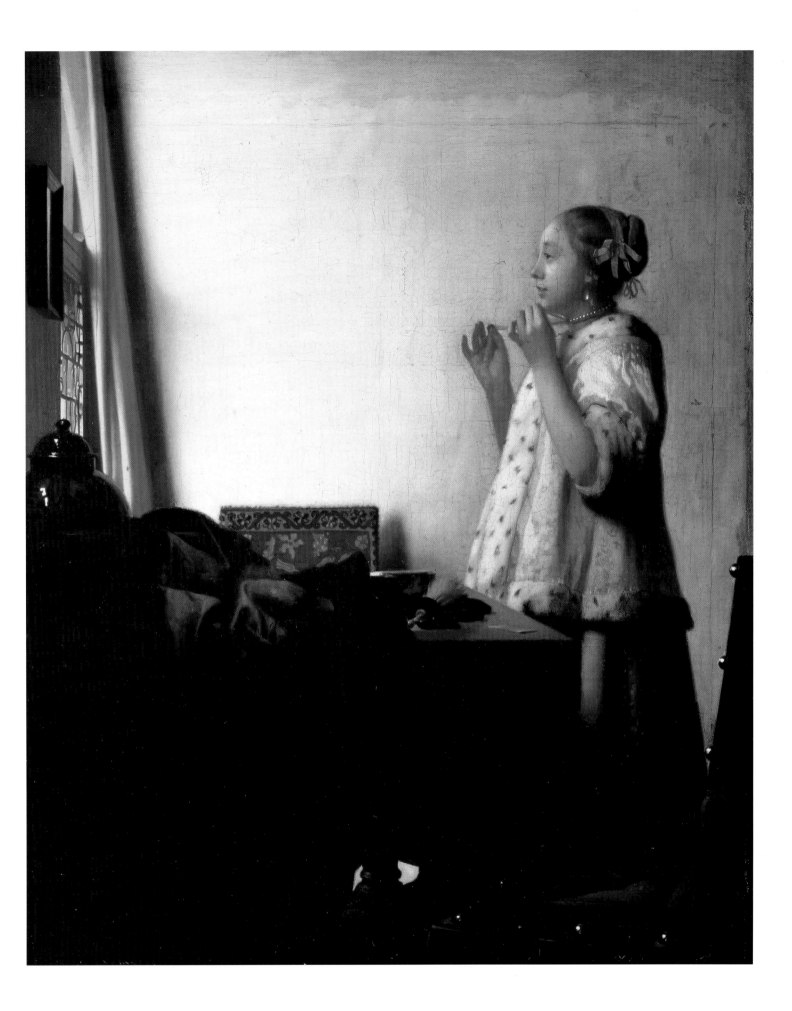

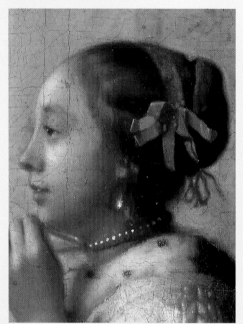
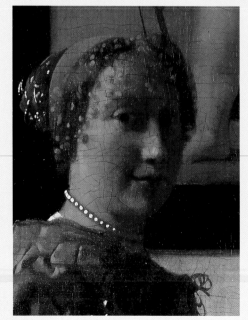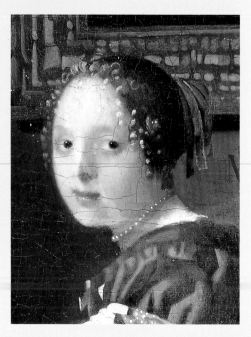

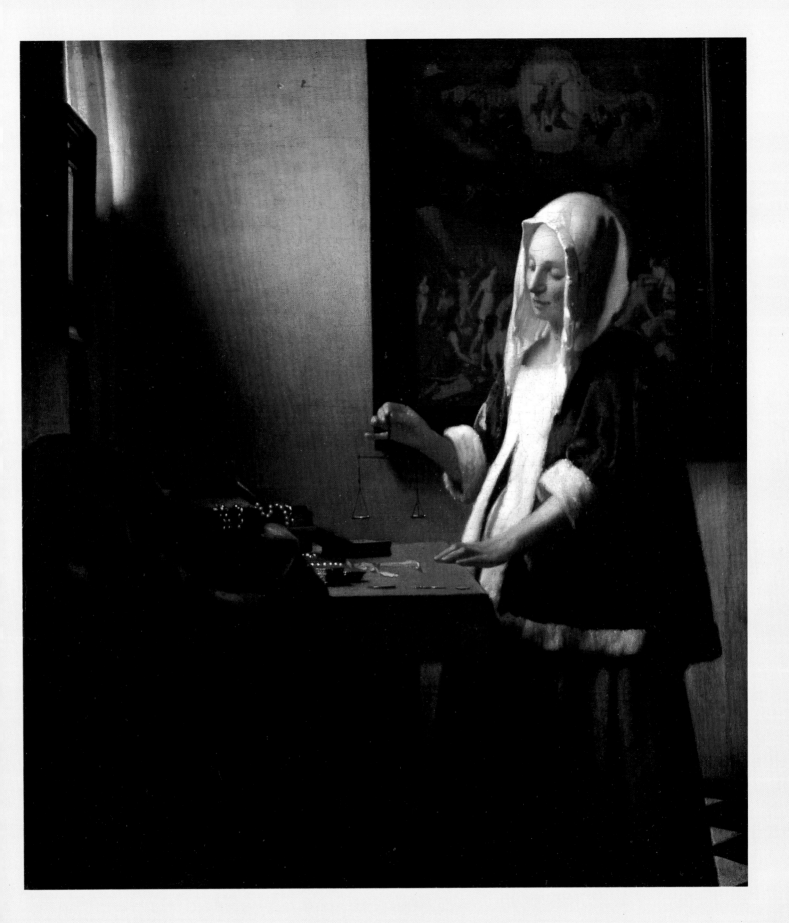

Woman Weighing Pearls, c. 1662–64
The painting of the Day of Judgement on the wall takes on the role of a
commentary on the woman weighing pearls. On the Day of Judgement,
Christ will weigh the souls of the Blessed and the Damned; in the
face of that, this fixation on earthly possessions appears empty and
vain. The women on the page opposite, decked out in pearls and
ribbons, are a reference to this theme of vanity.

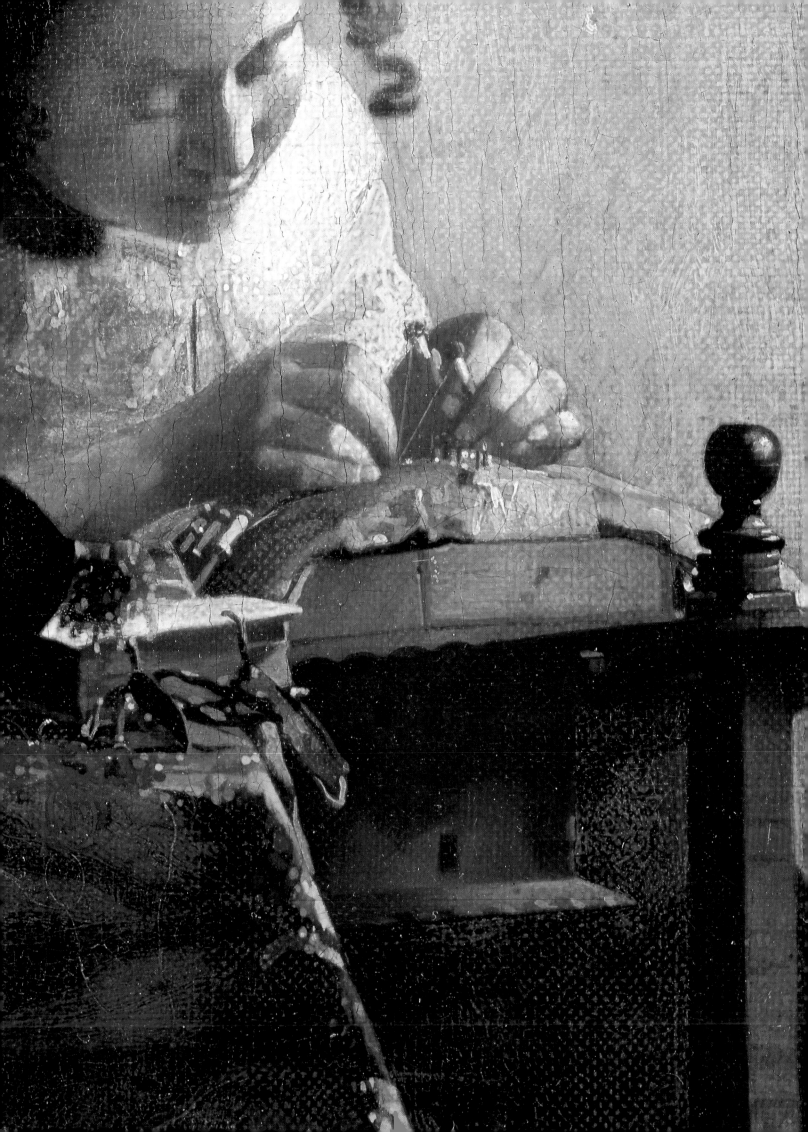

Leading by Example

Women and Virtue

The overwhelming majority of Vermeer's paintings that depict women conform to the basic trend in Dutch genre painting, in that they criticise vice. It was their goal to educate people to behave "virtuously" – in other words to conform to norms of thought and behaviour – and to do this by depicting, in a comic manner, characters behaving wrongly.

The opposite of this is to educate by presenting the official code of behaviour by means of an *exemplum virtutis* (model of virtue); this method was seldom used. Only three of Vermeer's paintings have this purpose clearly in mind.

The most famous of these is probably *The Milkmaid* (p. 65). It was valued highly right from the start, as is shown by the price (175 guilders) which this small picture fetched when the paintings in Vermeer's estate were sold in 1696. In 1719, the painting was even described with the words, "The famous milkmaid by Vermeer of Delft, artistic" (*Het vermaerde Melkmeysje, door Vermeer van Delft, konstig*).

Servants were normally portrayed in Dutch paintings as being lazy, as is shown by Nicolaes Maes' *The Lazy Maid* (p. 27), or lecherous. Although it is not immediately apparent, the latter vice is presented in Gerard Dous' *Kitchenmaid Chopping Onions* (1646); this interpretation is justified by the inclusion of onions (an aphrodisiac) and the hanging chicken (traditionally a sign of carnal desire). There is no such lewdness in Vermeer's painting of a kitchen maid. She is taking the business of carefully pouring the thick, curdling milk into a two-handled earthenware bowl very seriously. The maid's eyes are lowered in concentration, and this is a sign of humility and modest introspection. The bare room ties in well with the simplicity of the maid's way of life and actions. The greyish-yellow wall, with its conspicuous nails (and holes left by ones that have been removed) and cracks – silent testimony of long use – was originally, covered by a map, as has been shown by x-ray examinations of the painting. This would of course have been a symbol of luxury. It is therefore important that Vermeer should have later dispensed with this detail, as it develops the picture of the maid going about her simple everyday duties into something that is almost monumental, despite the small format. She is the embodiment of the "spiritual maid", who was repeatedly extolled in religious treatises. Vermeer's contemporaries would certainly have made religious associations with the milk, which the Bible describes as a "sincere" food (1 Peter 2, 2), and likens to "the first principles of the oracles of God" (Hebrews 5, 12). This religious metaphor still echoes in Schiller's phrase, the "milk of devout thought" (*William Tell*, IV, 3). The bread in the basket, and the rolls on the table, are speckled with shimmering points of light and are fascinating examples of Vermeer's wonderful pointillist technique. They, too, have similar religious connotations, given that Christ described himself as the "bread of life" (John 6, 48); it is not possible to miss this reference to the Eucharist.[20]

The Lacemaker (detail, see p. 63)

Books on household management required servants to make a great effort to behave in a god-fearing manner. It was felt that such views were the necessary basis, both for respect of their masters, whom they had to obey, and for an industrious attitude to life.

Vermeer's painting, which is now in New York, of the *Woman with a Water Jug* (p. 64), is a variation on this theme of virtue, but this time on a higher social scale, that of a middle-class housewife. This woman's eyes are also lowered modestly, and she is evidently pondering over the leaded windows, a motif which appears earlier in the Brunswick painting. It is not reproduced in any detail in the New York painting, however. What is presented, instead, is an emblematic personification of *Temperantia*, or temperance, which was considered a cardinal virtue. Hans Burgkmair's woodcut of a woman pouring water from a jug into a bowl is an example of the traditional way of representing this virtue. And this is the very scene that Vermeer depicts. A young woman is wearing a starched white headcloth and lace trimmings, the transparency of which has been very carefully observed by Vermeer. She is holding the handle of a shining, brightly glistening, gold-coloured jug, which, like the matching bowl, is reflecting the colours of nearby objects. A similar table set was painted by the Master of Flémalle (Robert Campin) on the right wing of the Werl altar (Madrid, Prado), as part of the symbolism relating to St. Barbara.[21] Like the golden censer and paten, this combination refers to the Holy of Holies in the Jewish Tabernacle. In contrast to this "sacred" object, Vermeer includes the jewellery box of pearls and blue ribbons. This contrast once again embodies conflict, both emotional and material: should this woman be vain and give in to self-love, or should she practise moderation?

Like *The Milkmaid*, Vermeer's *Lacemaker* (p. 63) is also completely absorbed in the concentration and effort required to carry out her work. From the Middle Ages, textiles and needlework had been seen as specifically feminine tasks. In his portrait of Anna Codde (circa 1530, Amsterdam, Rijksmuseum), Maerten van Heemskerck emphasised spinning flax at a distaff as being a feminine task typical of her. In the Book of Proverbs, the perfect wife is described as being "far above rubies" (31, 11ff.), and as always being busy with wool and with flax, setting her hands to the distaff and the spindle, and making her own quilts and linen sheets. This section of the Old Testament was repeatedly referred to in books on marriage written in and before the 17th century. Vermeer painted this scene in close proximity to his subject. There is one particular feature that suggests that an unfocussed camera obscura was used as an aid in the painting. It is the blurred edges of the colours, in particular of the yellowish-white and red threads, which seem to be streaming from the dark blue lace pillow with yellow stripes and curling up on the table rug (cf. p. 89). Vermeer's use of pointillism has an abstract effect on the image, blurring the other objects used by the woman, such as the lace pillow, the needles around which she threads the bobbins, and the pattern. This lacemaking equipment is very conveniently arranged on the wooden stand, quite a contrast to the bare room in which Caspar Netscher's *Lacemaker* (1664, London, Wallace Collection; p. 62) is working, using just a lace pillow.

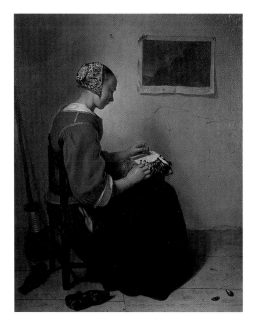

Caspar Netscher:
The Lacemaker, 1664

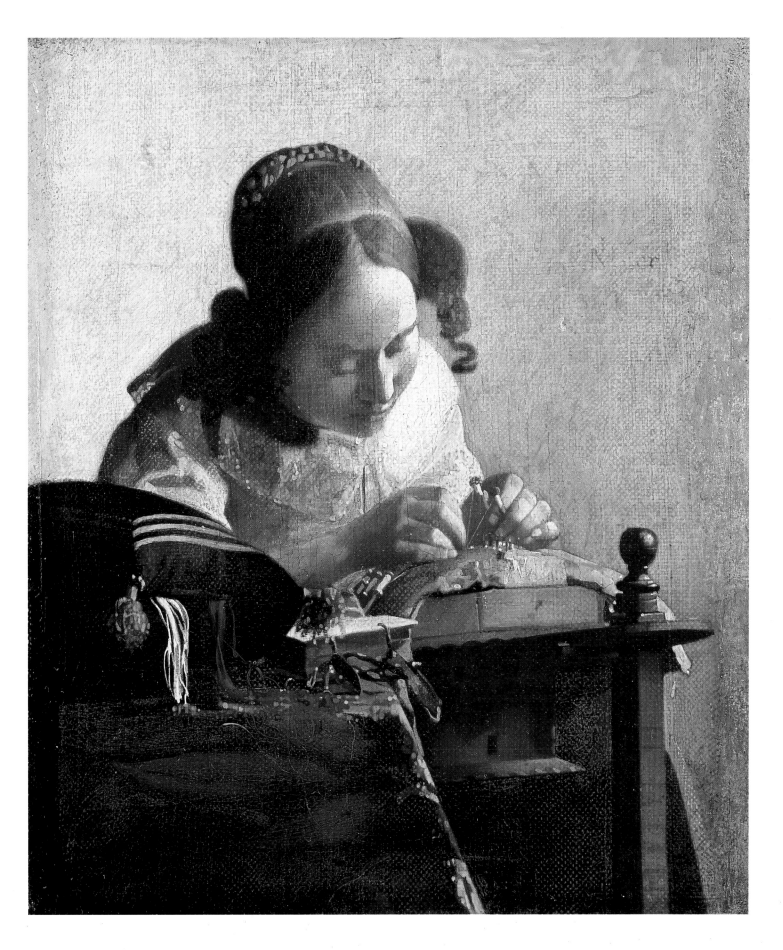

The Lacemaker, c. 1669–70
Her eyes lowered in humility, the lacemaker is concentrating,
nimble-fingered, on her task. Since the late Middle Ages, needlework
had come to be considered an occupation suited to women.

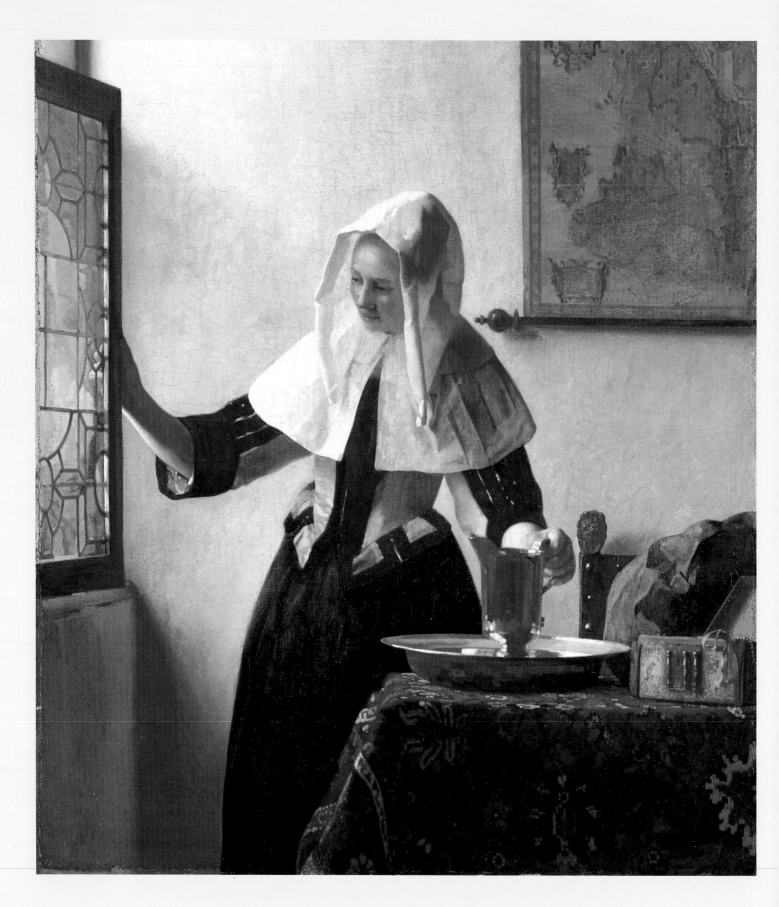

Woman with a Water Jug, c. 1664–65
This woman is torn between conflicting desires: should she give in to
vanity and her wish for admiration (the box of pearls), or should she
practise moderation (the water jug)?

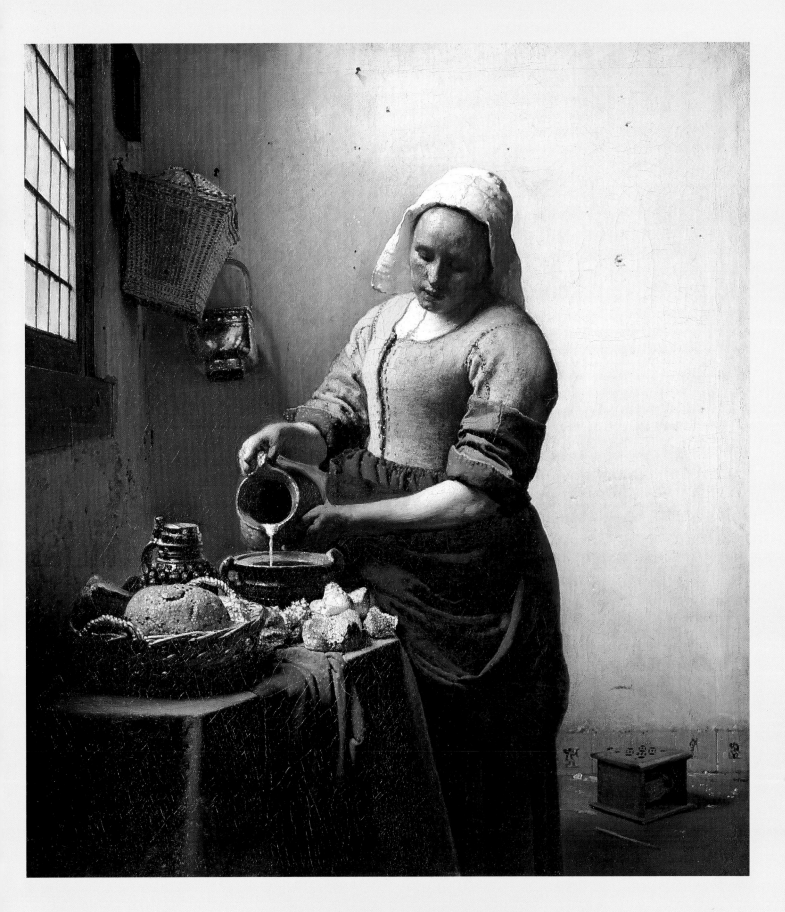

The Milkmaid, c. 1658–60
This is probably Vermeer's most famous painting. It has been valued
highly right from the start, as is shown by the comparatively high price
(175 guilders) which this small picture fetched when the paintings
in Vermeer's estate were sold in 1696.

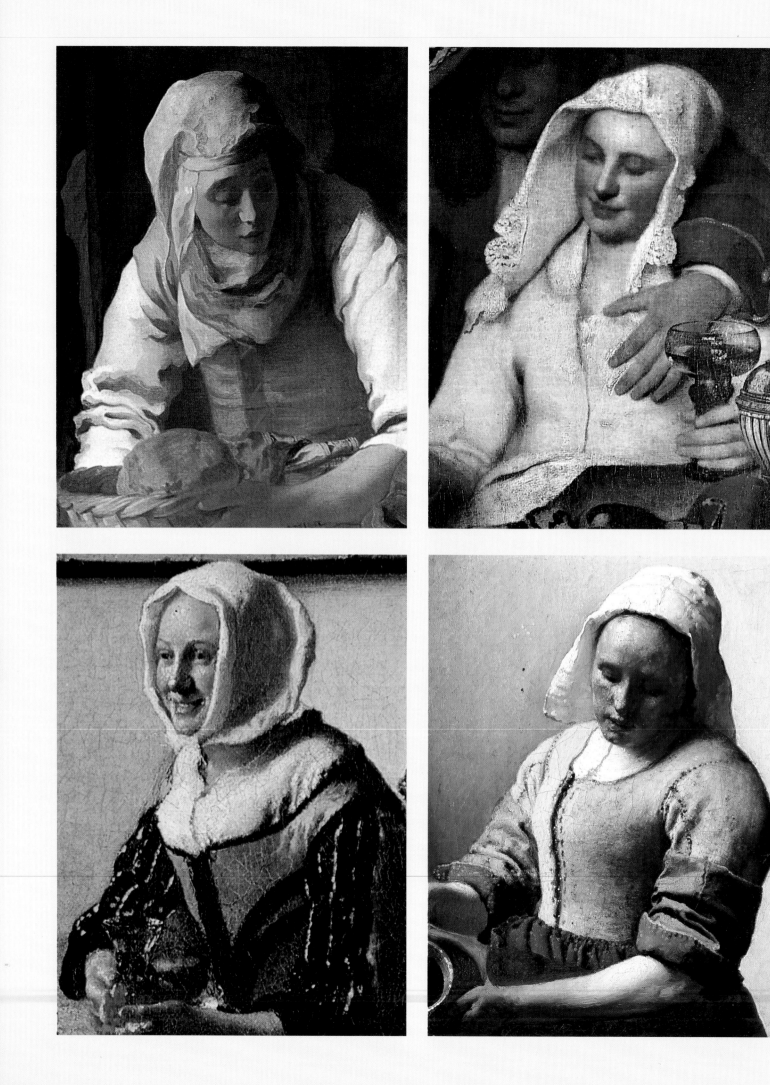

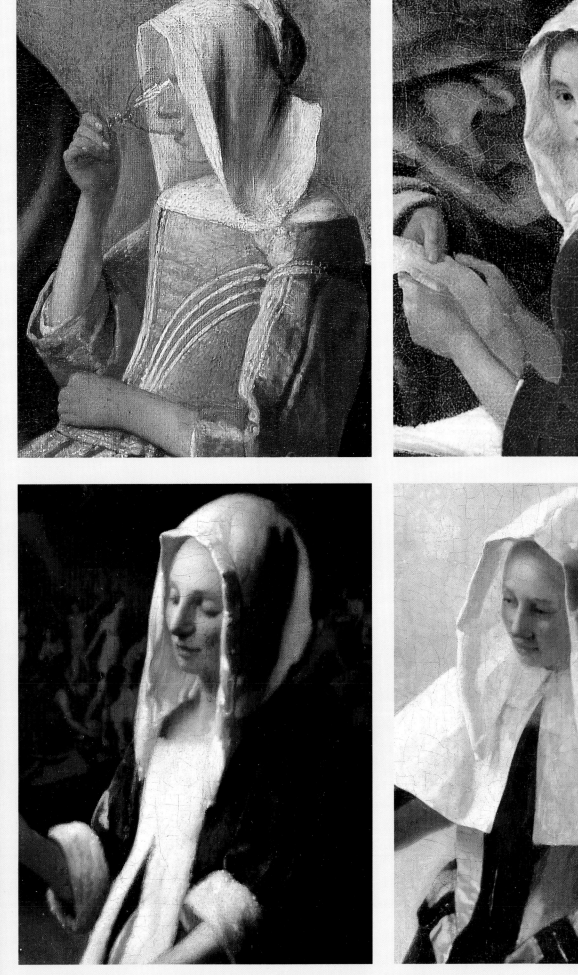

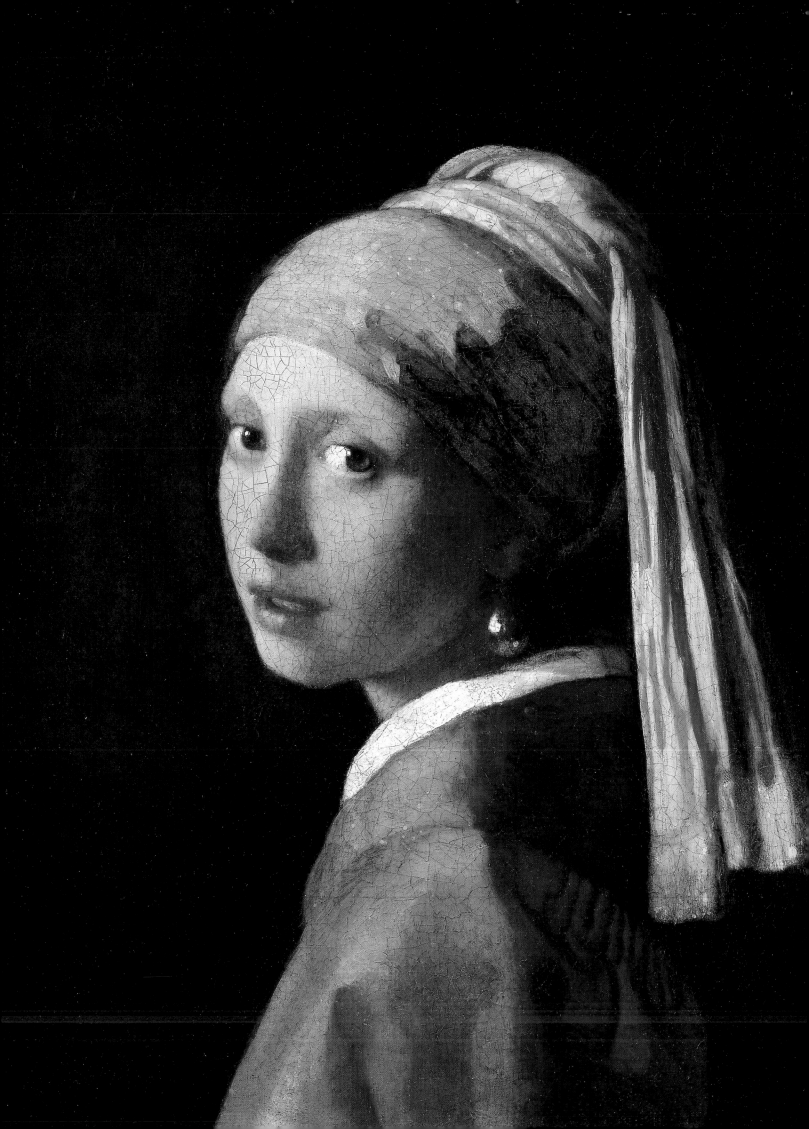

Turbans, Oriental Pearls and Chinoiserie

Portraits of Women

Vermeer predominantly depicted young women in a narrative situation, though this was often merely sketched in. The impression of an activity was created by his addition of some attribute, such as a musical instrument or a set of scales. In addition to these genre-type pictures, however, there are three paintings of his which completely lack any such elements. One cannot help concluding that these must be portraits, especially due to the fact that, in keeping with that genre, we see these women from a close perspective.

One is not forced to accept such a conclusion, of course, because some form of activity or mental action were important attributes in the interpretation of a number of portraits in and before the 17th century; and, at the same time, not every picture which appears to be in keeping with the style of a portrait has to be interpreted as a portrait, as having a conscious intention of creating an individualised character. In the case of the *portrait historié*, for example, where the subject frequently assumed a role in disguise, it is often difficult to decide whether the intention was to portray an individual, or whether the appearance of the model was merely being borrowed for a different purpose.

These considerations are pertinent to Vermeer's famous *Girl with a Pearl Earring* (p. 68), too. The girl is seen against a neutral, dark background, very nearly black, which establishes a powerful three-dimensionality of effect. (In fragment 232 of his *Treatise on Painting*, Leonardo da Vinci had noted that a dark background makes an object appear lighter, and vice versa.)[22] Seen from the side, the girl is turning to gaze at us, and her lips are slightly parted, as if she were about to speak to us. It is an illusionist approach often adopted in Dutch art. She is inclining her head slightly to one side as if lost in thought, yet her gaze is keen.

The girl is dressed in an unadorned, brownish-yellow jacket, and the shining white collar contrasts clearly against it. The blue turban represents a further contrast, while a lemon-yellow, veil-like cloth falls from its peak to her shoulders. Vermeer used plain, pure colours in this painting, limiting the range of tones. As a result, the number of sections of colour are small, and these are given depth and shadow by the use of varnish of the same colour.

The girl's headdress has an exotic effect. Turbans were a popular fashionable accessory in Europe as early as the 15th century, as is shown by Jan van Eyck's probable self-portrait, now in the National Gallery in London (p. 69). During the wars against the Turks, the remote way of life and foreign dress of the "enemy of Christendom" proved to be very fascinating. A particularly noticeable feature of Vermeer's painting is the large, tear-shaped pearl hanging from the girl's ear; part of it has a golden sheen, and it stands out from the part of the neck which is in shadow.

In his *Introduction to the Devout Life* (1608), which was published in a Dutch

Jan van Eyck:
Man Wearing a Red Turban, 1433
Turbans were a popular fashion accessory long before they were used by Vermeer, as we see in this probable self-portrait by Jan van Eyck.

Girl with a Pearl Earring, c. 1665
It is possible that this painting is a portrait. The girl is wearing an exotic turban, and the way she is gazing at us dreamily over her shoulder copies a style of portrait which was introduced by Titian's *Ariosto*. The girl is seen against a neutral, dark background, very nearly black, which establishes a powerful three-dimensionality of effect – a process recommended by Leonardo da Vinci.

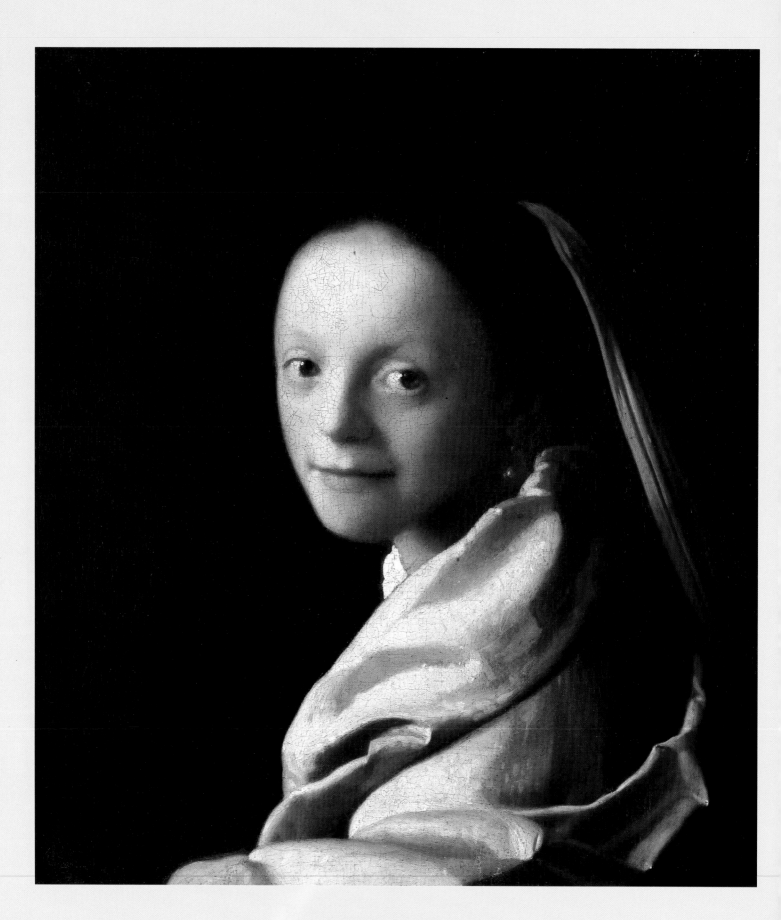

Head of a Girl, c. 1666–67

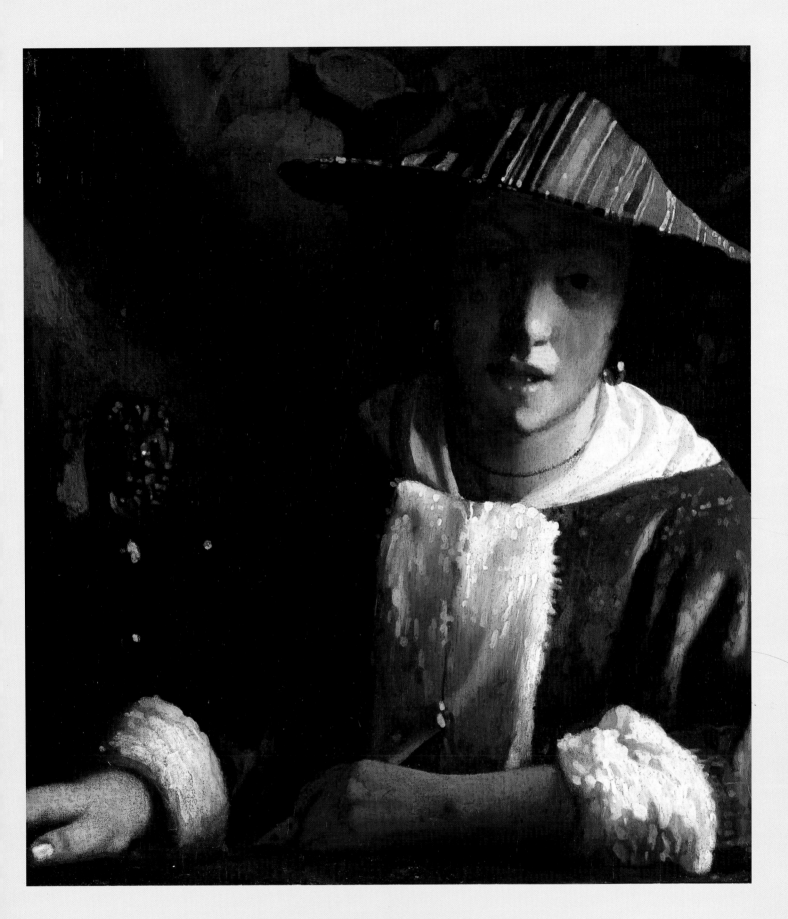

Girl with a Flute, c. 1666–67

A blurred photograph
The wood carving (below) was photographed using a rebuilt camera obscura. It produces the same effects as we can observe, on the lion's head on the chair, in Vermeer's painting – dots of light and blurred edges.

translation in 1616, the mystic St. Francis De Sales (1567–1622) wrote, "Both now and in the past it has been customary for women to hang pearls from their ears; as Pliny observed, they gain pleasure from the sensation of the swinging pearls touching them. But I know that God's friend, Isaac, sent earrings to chaste Rebecca as a first token of his love. This leads me to think that this jewel has a spiritual meaning, namely that the first part of the body that a man wants, and which a woman must loyally protect, is the ear; no word or sound should enter it other than the sweet sound of chaste words, which are the oriental pearls of the gospel."[23]

From this it is clear that the pearl in Vermeer's painting is a symbol of chastity. The oriental aspect, which is mentioned in the above extract, is further emphasised by the turban. The reference to Isaac and Rebecca suggests that this picture could have been painted on the occasion of this young woman's marriage. So to that extent it is a portrait.

There is surely a similar explanation for the *Head of a Girl* dressed in a smart, grey dress. Many experts on Vermeer have placed this painting (p. 70) among his later ones; since 1979 it has been in the Metropolitan Museum of Art, New York. Though more discreet, there is another pearl earring in this picture. The composition is also related to the other painting. Once again, we see this woman from the side, looking over her shoulder, though her face is turned further towards us. Her black hair is combed back severely from her forehead, and is plaited together with her (bridal?) veil. An additional variant is the position of her left arm, which is bent up against a parapet. Vermeer is following a style of portrait which was introduced by Titian's *Ariosto*.

The *Girl with a Flute* (p. 71), which is part of the Widener Collection in Washington, depicts a young girl who is largely detached from the uncertain context of the picture. We see her from a very close angle, leaning on the edge of a table which has been foreshortened to the point where it looks more like a parapet. Again, her lips are lightly parted as she looks at us, as if she were about to speak to us. Her face, and in particular her eyes, are shadowed due to her wide, conical hat; it takes on the appearance of exotic chinoiserie. The way in which her face has been painted in shadow lends a touch of the enigmatic to her features.

Vermeer repeated this posture of the arm in the painting *Girl with a Red Hat* (p. 73), though she is seen from the other side, and is therefore leaning on her right arm, against the backrest of a chair decorated with lions' heads and rings. This picture was quite evidently painted with the aid of a camera obscura. That is indicated by his use of pointillism, bright dots of paint and occasional highlights on the folds. The light is falling at an angle from above onto her soft, feathery hat; on the top it is vermilion, and the lower shadowed part is a dark purple colour. The intensity of the light is such that the hat appears, at points, to be transparent. Its broad brim has the effect of casting a shadow over most of her face; only her left cheek, below her eye, is lit. The shading of her eyes, the centre of her face, is quite intentional; the principle of *dissimulatio*, a mysterious disguise, is being applied here, the intended effect being to heighten our curiosity.

Girl with a Red Hat, c. 1666–67

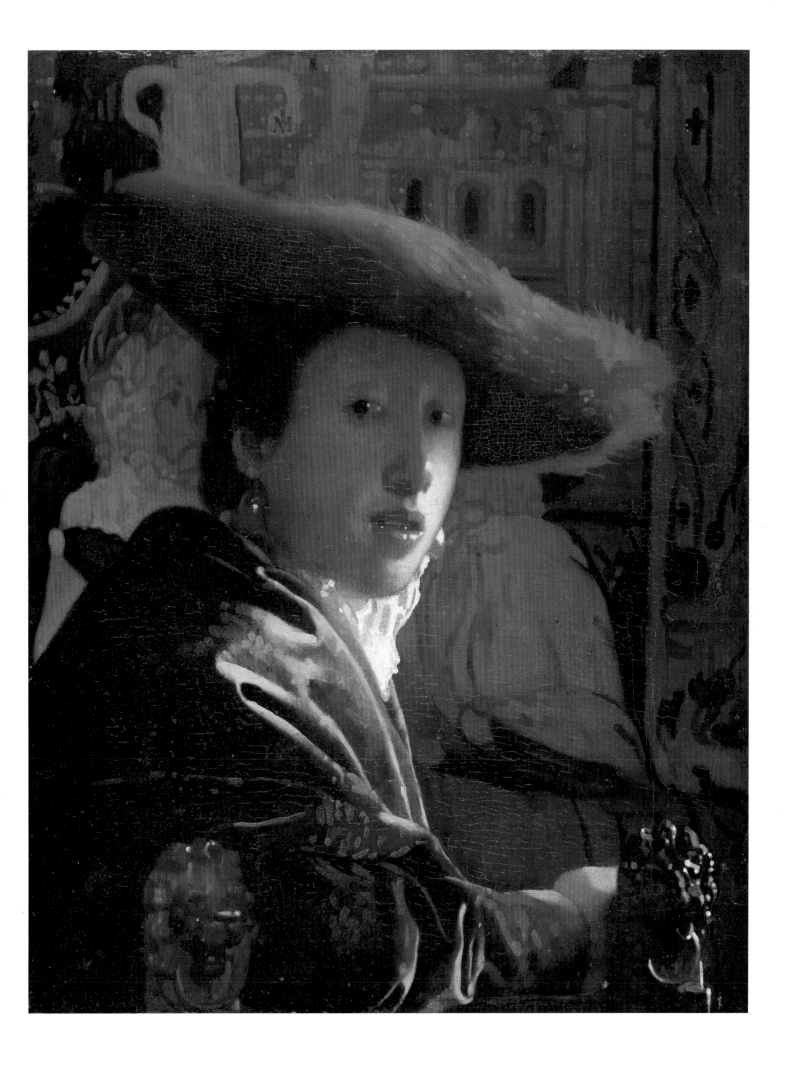

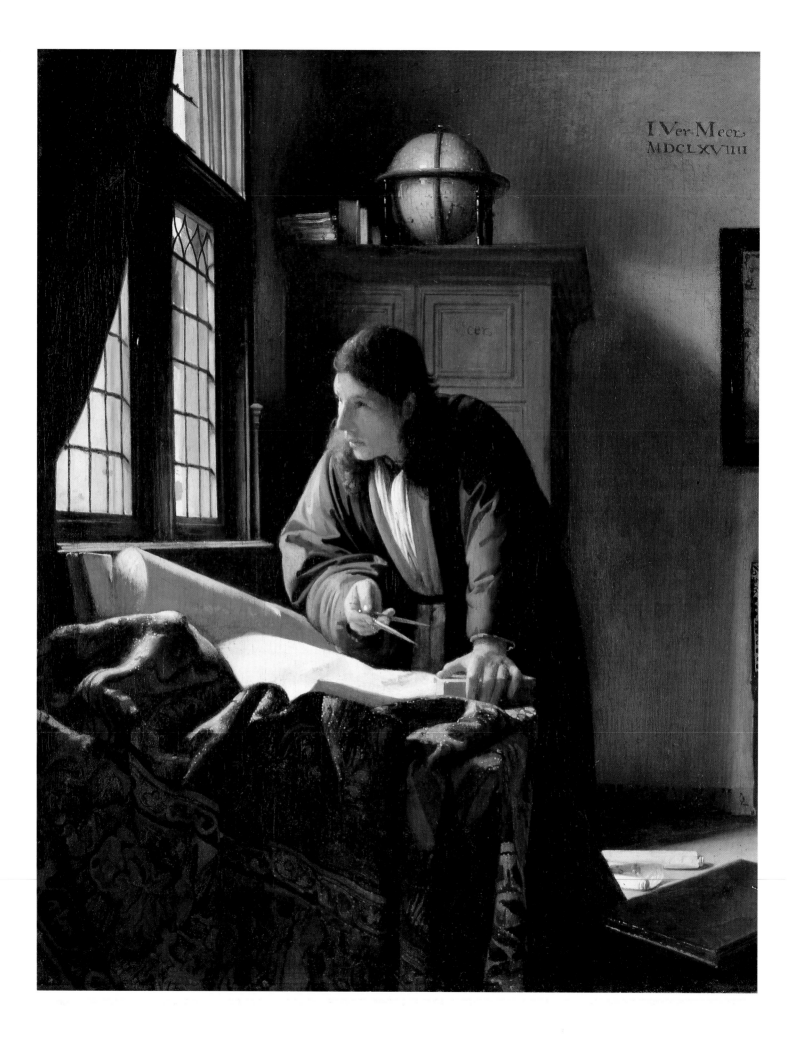

The New Science

Geography and Astronomy

Only three of Vermeer's works can be dated and authenticated precisely; one of them, the 1668 painting *The Astronomer* (p. 76), now hangs in the Louvre. Due to the similar motif and size, it is safe to assume that this painting was conceived as a counterpart to the Frankfurt painting *The Geographer* (p. 74). Both paintings depict an academic, with long hair that is tucked behind his ears, and wearing a robe-like garment that reached to the floor and was not normal everyday attire. This gave these figures an air of mystery, as if they belonged to the chosen few. They are going about their business behind closed doors. The astronomer is not using a telescope, but is at his desk, checking descriptions in an open book against the constellations on his celestial globe. He is using his right hand to hold the globe in a precise position, and we can make out the constellations of the Great Bear (on the left), the Dragon and Hercules (centre), and Lyra (on the right).

James Welu has established that the globe was made by Jodocus Hondius (p. 77), and he has even been able to identify the book. It was written by Adriaen Metius and its title is *The Exploration and Observation of the Stars*. Behind the billowing table carpet it is possible to make out an astrolabe that has been laid down flat; this was an instrument of greatest importance to both astronomy and navigation, as it made it possible to measure angles and ascertain one's position.

The geographer is using compasses to check distances on cartographic plans, the precise details of which cannot be made out. He pauses as he does so, and looks thoughtfully to the window; the light shining through it lights up his face, a sign of inspiration.

Vermeer painted both pictures at a time when a radical change of paradigm was taking place in science. The teachings of conservative humanists such as Sebastian Brant continued up to the middle of the 17th century. They taught that it would be presumptuous, and an improper interference in the divine scheme of things, to attempt to discover the nature of the stars and the history, size and composition of the Earth. They imposed a ban on *curiositas*, scientific inquiry, and on any science based on experience and empirical research. In Brant's *Ship of Fools*, in the chapter headed "Of the Discovery of all Countries",[24] it says that classical scientists such as Archimedes and Pliny were careful not to give away their discoveries, or to delve too deeply into the way these were interrelated.

The Astronomer was painted as Louis XIV was building an observatory in Paris (1667–72). In 1668, a young Isaac Newton improved on the design of the reflecting telescope which James Gregory had developed in 1663. A decade previously, Christian Huygens of The Hague had discovered Saturn's sixth satellite with his telescopes. Astronomical activities such as these were of great practical

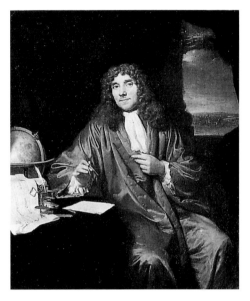

Jan Verkolje:
Antoni van Leeuwenhoek, undated
Antoni van Leeuwenhoek (1632–1723) was born in the same year as Vermeer. He was a wealthy cloth merchant, and he experimented with a variety of optical instruments, in particular with the 247 microscopes that he built himself. His discoveries include spermatozoa and bacteria. He was in close contact with the Royal Society in London, and kept them informed of the results of his research. After Vermeer's death, he was appointed trustee of his estate.

The Geographer, c. 1668–69
With the exception of *The Procuress*, *The Geographer* and *The Astronomer* are the only dated works of Vermeer's. These two paintings were produced as a pair, and remained together until 1729.

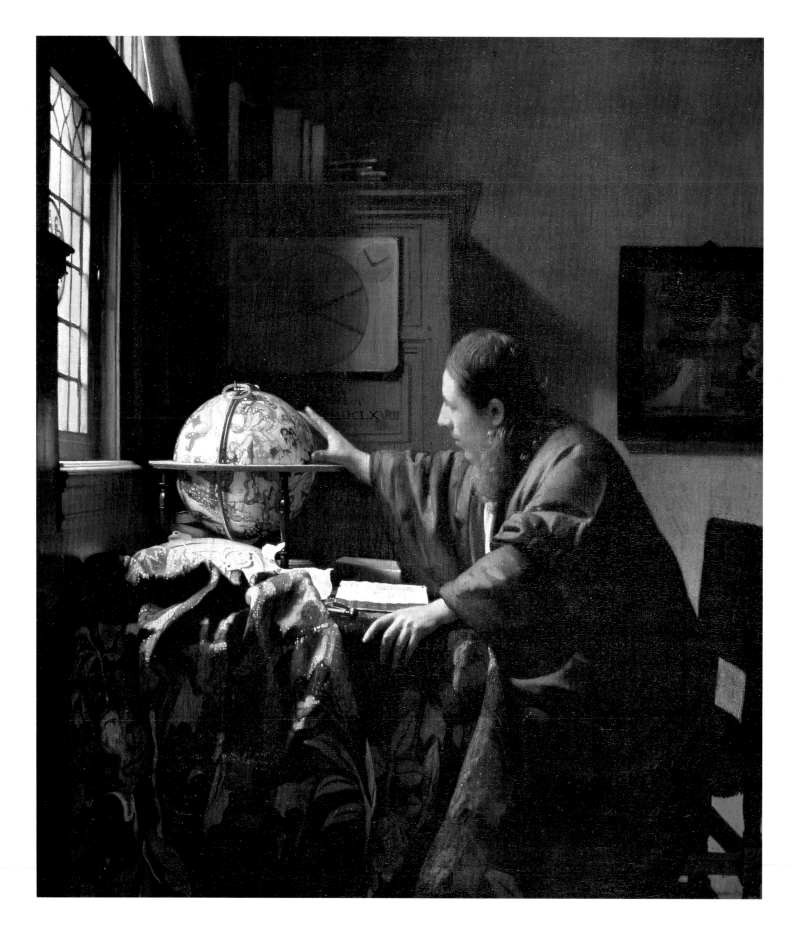

The Astronomer, c. 1668
It has proved possible to identify the book that lies open in front of this
mystically-clad astronomer. It is by Adriaen Metius and is called
The Exploration and Observation of the Stars.
The globe was made by Jodocus Hondius (cf. p. 77).

importance for navigation, and in the broadest sense they served (maritime) trade.[25]

Such practical considerations and empirical approaches seem to have played little part in Vermeer's astronomer picture. It is typical enough that this astronomer should be working indoors, without looking through the window at the heavens as Gerard Dou's *Astronomer* does. This suggests that he could be devoting himself to the older, non-empirical science of astrology, or, in other words, that he is drawing up a horoscope. The transition from astrology to astronomy was still in progress at this time. It is known that astronomers such as Johannes Kepler and Tycho Brahe, who were dedicated empiricists, were still practising astrologists. The moment of birth, the stars at nativity, are of key relevance to the forecasting of the future by means of a horoscope; and the concern of Vermeer's painting with this fact is suggested by the picture on the wall, which shows the finding of the infant Moses (Exodus 2, 1–10). The birth of Moses was considered to be a prefiguration of the birth of Christ; Christian teaching therefore perceived a connection between the two, a link grounded in cosmology. The persecution of the children of Israel, including Moses, who was famously left amid the rushes, was compared with the Holy Family's flight to Egypt from Herod's Massacre of the Innocents at Bethlehem.

James Welu, who has inferred the likeliest passage in the work by Adriaen Metius open in front of the astronomer, contends that Metius' accounts of the earliest astronomers were taken by Vermeer to apply to Moses, since the latter (according to Acts 7, 22) was supposedly learned in the wisdom of Egypt, which would have meant astronomy in particular.[26] The question remains, however, why Vermeer should have chosen this specific episode in the story of Moses, which relates in no way to any ability he may have had as an astronomer. As we have seen, Vermeer used this picture of the finding of Moses in a different context (p. 55), in specific allusion to the circumstances of Moses' birth, rather than merely to his person.

Vermeer's *Astronomer* does not make any unambiguous statement on its scientific content. Astrology is not definitely rejected, but neither does the picture argue the case for the new science of astronomy. The geographer is perhaps working more within the terms of our modern understanding of the exact sciences, since the nautical chart on the wall (Willem Jansz. Blaeu's sea chart of Europe, "*PASCAARTE/van alle de Zëcusten van/EVROPA*"; size of the original 66 x 88 cm), in contrast to the Moses painting, points not to spiritual dimensions but to the practical uses of science in describing the world for the purposes of navigation. In the late 1660s, questions of maritime trade were much on the Dutch nation's mind. Admiral de Ruyter had brought the Second Anglo-Dutch War (1665–67) to a victorious conclusion; this war was fought over supremacy in the North Sea, over fishing rights, and to protect the Dutch merchant fleet, which had been endangered by protective measures that the English government had taken in favour of its own merchants.

Hard Times
A few months after Vermeer's death, his widow was officially declared bankrupt. This is the comment which Antoni van Leeuwenhoek, in his capacity as trustee, added to the Delft annals.

Jodocus Hondius:
Celestial Globe, 1618
This is the globe which Vermeer included in his painting *The Astronomer*.

"Painted Powerfully and Full of Warmth"

Allegory of Faith

There are two paintings of Vermeer's whose themes differ fundamentally from those of his other, more realistic and everyday pictures. Both have elements of allegory about them, and both set out to realize abstract concepts. One of them portrays a personification of Faith (p.80); the other shows one of the Muses fitted out with her attributes (p.83), and she is the key to this painting's meaning.

Herman van Swoll's Amsterdam catalogue, dated 22.4.1699, describes the *Allegory of Faith* as follows: "A woman seated, various interpretations, represents the New Testament, by Vermeer of Delft, is painted powerfully and full of warmth" (*krachtig en gloejent geschildert*). The price was set at four hundred guilders, which was a remarkably high figure evidently seeking to do justice to the painter's learned theme, to the painting's size (114.3 x 88.9 cm), and certainly also, as the above comment reveals, to the quality of the painting.

Vermeer studies have long expressed doubt as to whether it is at all correct to identify the theme of this painting as New Testament. A. J. Barnouw demonstrated convincingly in 1914 that Vermeer obviously used Cesare Ripa's *Iconologia* (translated into Dutch by Dirck Pers in 1644); most of the elements employed by Vermeer in his painting appear here as attributes of the allegory of faith, and do not therefore refer to the New Testament. Imprecise or even incorrect identifications of the theme, such as that in the sales catalogue, are more understandable if one takes into account the fact that they were written by amateurs who no longer knew the original intentions of the artist (Vermeer had died twenty-four years before).

Cesare Ripa wrote: "Faith is represented by a sitting woman, who is reverently holding a chalice in her right hand and is resting her left hand on a book which is lying on a solid cornerstone; the latter represents Christ. The world, a globe, lies at her feet. She is dressed in sky blue, with a crimson outer garment. A crushed serpent, and Death, whose arrows have been broken, lie behind the cornerstone. Nearby is an apple, the source of Sin. Behind her, a crown of thorns hangs on a nail..." Vermeer did not slavishly follow all these instructions, though it is true that he did keep to most of them. As a result, the red dress, the death motif, and the crown of thorns are all missing, though the latter appears in the painting on the wall, which portrays the crucifixion of Christ as the mystery of faith.

Vermeer probably borrowed the glass ball, which hangs down from the wooden beamed ceiling, from Willem Heinsius' book of emblems (*Emblemata Sacra de Fide, Spe, Charitate*. Antwerp, 1636), where it was described as a symbol of man's power of reason. This object was originally of prime importance in the art of prophecy, in particular of crystallomancy, divination by means of a crystal ball.[27]

Vermeer moved his scene to the interior of a middle-class home. It is prob-

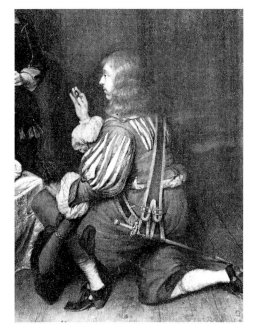

Caspar Netscher:
The Locket (detail), c. 1665–68
Slitted waistcoats were widely worn in the first half of the sixteenth century. However they are also a feature of many seventeenth-century genre paintings.

The Art of Painting (detail, see p.83)

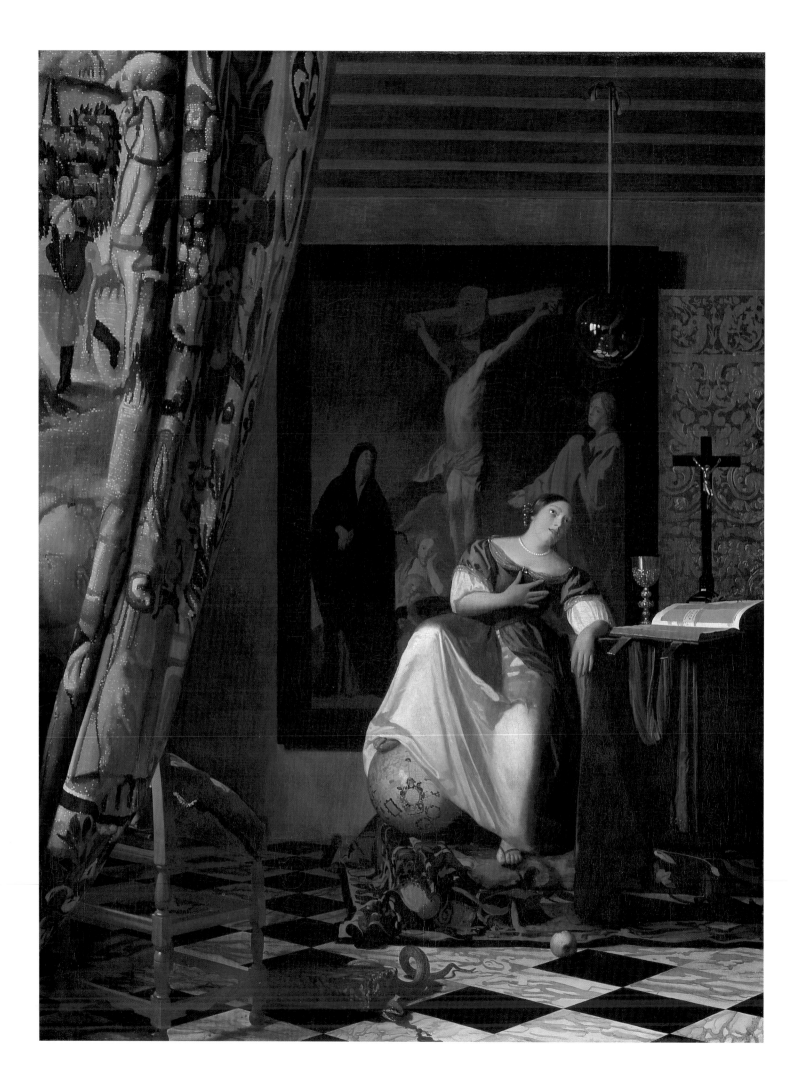

able that it was one of the larger rooms in the house of his mother-in-law, Maria Thins, whom he and his family lived with; her house provides the setting for many of his genre paintings. The combination of the abstract, bloodless theme of this painting and its everyday "realism" has appeared to many writers on Vermeer to be quite grotesque. Particular points that have given rise to negative judgements are the way Fides is pathetically clutching at her heart, looking skywards (which today seems rather bigoted), and sitting in a complicated posture with her right foot placed on the globe. Arthur Wheelock Jr. said as recently as 1988, "As a work of art it is a failure", and John Nash agrees with this when he says, "It is an odd, unconvincing work".[28] On the other hand, it must be emphasized that Vermeer's contemporaries judged the painting altogether more positively, as is proved by the high set price. Where the setting is concerned, it should be remembered that this painting is quite in keeping with the tradition of Old Dutch painting (van Dyck and his successors); the application of religious motifs to everyday situations was typical of their work. The purpose of this was to bring the faithful closer to Biblical matters, and to make them experience such as something that closely affected their own lives.

Vermeer's *Allegory of Faith* is generally considered to have a Catholic tenor. It has been assumed that the painting was commissioned by the padres of the Delft Jesuit mission, as its symbolism is also related to Jesuit iconography. But there is no firm proof to support this theory.

It is interesting that Vermeer used a globe produced by Hondius in 1618, and it is no accident that its cartouche is turned towards us. Its inscription praises Prince Maurits of Nassau-Orange (1567–1625), who at that time was the Dutch governor. Vermeer was undoubtedly making a political statement by doing this, in the sense that he was demonstrating his allegiance to the House of Orange. Many Delft artists (such as Bramer, Couwenbergh and Houckgeest) shared this attitude, and many of them worked for the Hague court. It is also surely correct to identify the heraldic symbols which adorn the tapestry curtain on the left (a feature Vermeer always used as a motif of revelation) as belonging to the family of this governor. On the one hand there is the orange, on the other a Burgundian lily (top). As descendants of the House of Chalon, members of the House of Orange were titular governors of the *Franche-Comté* of Burgundy, whose coats of arms included the *Fleur de lis*.

The Artist's Studio

Vermeer's famous *Allegory of Painting* (p. 83), now in Vienna, is seen by many art historians as a programmatic statement, and indeed his testament as an artist.[29] This feeling is expressed by the title which many critics, including Sedlmayr, have given the painting: *In Praise of the Art of Painting*. This adds to the old, and rather more neutral, account in the notary's records, dating from 24 February 1676, when the painting was transferred from Vermeer's widow Catharina Bolnes to her mother, Maria Thins, in order to pay off her debts. There the painting is described as "A painting, painted... by her late husband, and representing the Art of Painting" (*warinne wert uytgebeelt de Schilderconst*). Once again, as with the *Allegory of Faith*, amateurs gave the picture a title which does not properly match its iconographic subject matter. The reason is as follows: the young woman wearing a blue silk robe and yellow skirt and a crown of leaves, holding a trombone in her right hand and a book with a yellow cover in her left, is in no way an allegory of the art of painting (*schilderconst*, Lat. *pictura*); rather – and there is now no doubt about this – she is the Muse Clio, the patron of history.

For a second time, Vermeer was following an outline given in Cesare Ripa's *Iconologia* (in the above-mentioned Dutch edition). The theme of Vermeer's

Allegory of Faith (detail, see page 80)
A symbol of man's power of reason
The glass ball which hangs from the ceiling was borrowed by Vermeer from Willem Heinsius' book of emblems; it was described there as a symbol of man's power of reason.

Allegory of Faith, c. 1671–74
Vermeer's *Allegory of Faith* included many of the details in Cesare Ripa's *Iconologia*, which was published in Dirck Pers' Dutch translation in 1644 and stated how Fides should be represented.

painting is therefore not the art of painting, but history, and in particular the history of famous military victories. This does not of course alter the fact that the painter undoubtedly has a central role in the painting; we see him from behind, anonymous, sitting on a stool in front of his easel, busy painting part of Clio on an otherwise empty canvas. Since the Renaissance, an empty canvas had been a symbol of *concetto*, of artistic inspiration, which takes on palpable shape during the act of painting.

The painter is shown in the process of painting; Vermeer is showing him in a serving role, and therefore this picture cannot be praising the art of painting. The painter is praising not Pictura, but Clio instead, and through her History, or, to be more precise, a particular historical event.

Again the scene is set indoors, perhaps even in Vermeer's own studio, as is suggested by the heavy oak table on the left, which is mentioned in his mother-in-law's inventory. On it are various props which were previously thought to refer to the theory of art. It was assumed that Vermeer was concerned with the problem of the rivalry between the arts, as discussed by Leonardo da Vinci. Painting, understandably enough, was victorious over sculpture, which is symbolised by the mask on the table. The upright book, open folio and silk cloths can admittedly not be explained within this context. Neither can the relationship of Clio to these objects. Is the way she is lowering her eyes to be interpreted psychologically as shyness? Is it not, rather, possible that Clio is looking upon the props as symbols that support her own meaning? If that were the case, they might well tie in with a particular historical event. But what event could that have been? A key to this problem could be the map which covers a large part of the wall. It was produced by Claes Jansz. Visscher (Piscator) about 1692 (cf. p. 34). It is strange – and this is something that has worried many Vermeer critics – that he should have chosen to go back to a point of time in Dutch political geography which was long out of date, for the map shows not the region of the Republic of the northern United Provinces, but – as is also clearly signalled by the inscription – the seventeen former provinces, as they were before peace was agreed with Spain in 1609.

The map is bordered on either side by views of cities (on the left, Brussels, Luxembourg, Ghent, Bergen, Amsterdam, Namur, Leeuwarden, Utrecht, Zutphen and T'Hof van Hollandt in The Hague; on the right, Limburg, Nijmegen, Arras, Dordrecht, Middelburg, Antwerp, Mechelen, Deventer, Groningen and T'Hof van Brabant in Brussels). James Welu has pointed out that Clio is holding her trombone in front of the view of the Dutch court in The Hague, which was the residence of the House of Orange (the trombone was a traditional symbol of *gloria*, or fame; Clio derives etymologically from the Greek *kléos*, or fame).

Vermeer is evidently making a discreet point here. His intention appears to have been to pay homage to the fame of the House of Orange. But what could lead him to wish to honour them in this way? One must bear in mind that the governor, who was a member of the House of Orange, had gradually been losing his position of authority. In 1653, Jan de Witt (1625–1672), the highest elected officer of the *Staten-Generaal* and in receipt of a Council pension, had brought about the exclusion of the House of Orange from state office under the secret *Acte van seclusie*. The *Eternal Edict* even withdrew the rank of military commander-in-chief from the young governor, William III (1650–1702). All of this, which supporters of the governor's party felt to be humiliating, changed at a stroke when Jan de Witt's regent's party was put on the political defensive due to the clumsy way it had led the country in the war against France. The only way de Witt had managed to repel Louis XIV's troops as they invaded the Netherlands was to open the dykes and flood land. This move, however, caused great damage to the country's agriculture. Displeasure grew among the popula-

The Art of Painting, c. 1666–1673
The woman wearing the crown of leaves, holding a trombone in her right hand and a book in her left, is Clio, the Muse of History. It is unlikely that Vermeer intended to praise the art of painting, as has so often been stated; rather, this allegorical figure appears to be referring to an actual historical event.

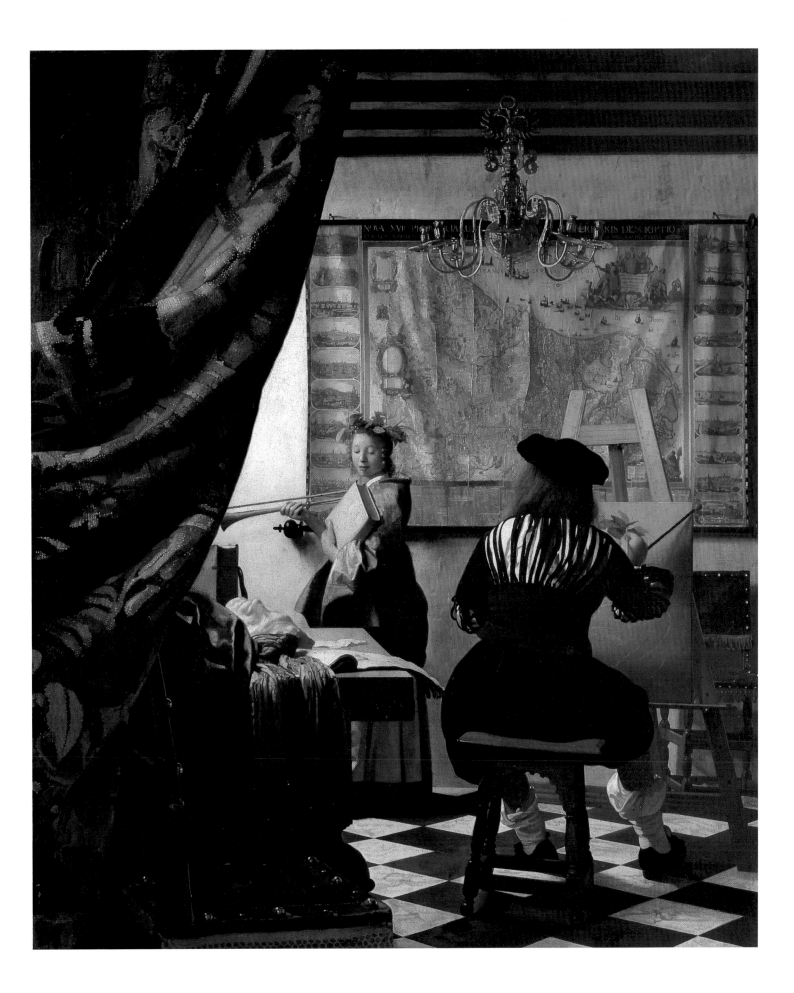

The Love-Letter (detail, see p.54 right)

The Milkmaid (detail, see p.65)

In 1888, Vincent van Gogh wrote to Emile Bernard:
"It is true that in the few pictures he painted, one can find the entire scale of colours; but the use of lemon yellow, pale blue and light grey together is as characteristic of him as the harmony of black, white, grey and pink is of Velázquez."

ILLUSTRATION PAGE 85:
The Art of Painting (detail, see p.83)

tion, until at last he and his brother Cornelis were murdered by an angry mob. This was on 20 August 1672. Now all hopes were pinned on the young governor, William III, who assumed overall military control and was victorious due to clever tactical alliances.

Everything points to Vermeer having painted this picture within the historical context of the Franco-Dutch War of 1672–78, and not, as was thought before, in the mid-1660s. Further support for this hypothesis is the chandelier with the Habsburg two-headed eagle; it is no accident that it is painted just above the top of the map and overlaps with the inscription *OCEANUS GERMANICUS*. The term *GERMANIA INFERIOR*, which was the old Latin name for the Netherlands, appears to the right. All these are signs of a positive attitude towards the (Germanic) Holy Roman Empire, and cannot be coincidences; nor are either the two-headed eagle or the map of the seventeen provinces familiar features of 17th-century Dutch art. They must, therefore, have been included for a particular reason. That reason must have been the alliance which was formed against France on 30 August 1673 by William III and the Habsburg Emperor, Spain and Lorraine. The hopes which were raised by this alliance were sufficient to dispel any remaining aversions which the Dutch may have felt towards the House of Habsburg, whose rule they had fought against a century previously.

Visscher's map, which appears in Vermeer's painting, conjured up memories of the old Burgundian Empire, in which William I of Orange had played an important political role. It should not be forgotten that before he became the leader of the resistance, forced into that position more by circumstances than political conviction, he was a favourite of Charles V, who made him Governor of Holland, Zeeland, Utrecht and the Burgundian *Franche-Comté*. The *Franche-Comté* was the most fiercely fought-over area during the Franco-Dutch War; Louis XIV did not conquer it until spring 1674. This aspect is alluded to by Vermeer's clothing his painter in Burgundian dress of the early 16th century. Since Clio, as Muse of History, draws a veil of glory over military success, the painting was presumably intended to convey confidence of victory; it can only have been painted before the loss of the *Franche-Comté*, in other words at a time when the Dutch still hoped to save it from conquest. This points to a date in the last third of 1673.

The props on the table are presumably Vermeer's way of alluding to William I, who united all the Dutch provinces in the Ghent Concorde of 1576. It is possible that Vermeer is also referring to the magnificent tomb of the House of Orange in the Delft Nieuwe Kerk, which was created by Hendrick de Keyser. There, too, a *fama* holding a trombone appears, at the feet of the marble statue of William on the tomb. The mask lying on the table in the painting, which has noticeably individualised features, could be based on the head of the figure on the tomb, or on a terracotta mask of William I by Hendrick de Keyser which is in the Prinsenhof in Delft.

Older interpretations of this painting were based on a 20th-century understanding of art, and considered the picture to be in praise of the art of painting, or a glorification of the profession of painting; in contrast to these, what should be emphasised more strongly is its political meaning, Vermeer making a statement on the historical events of the day.

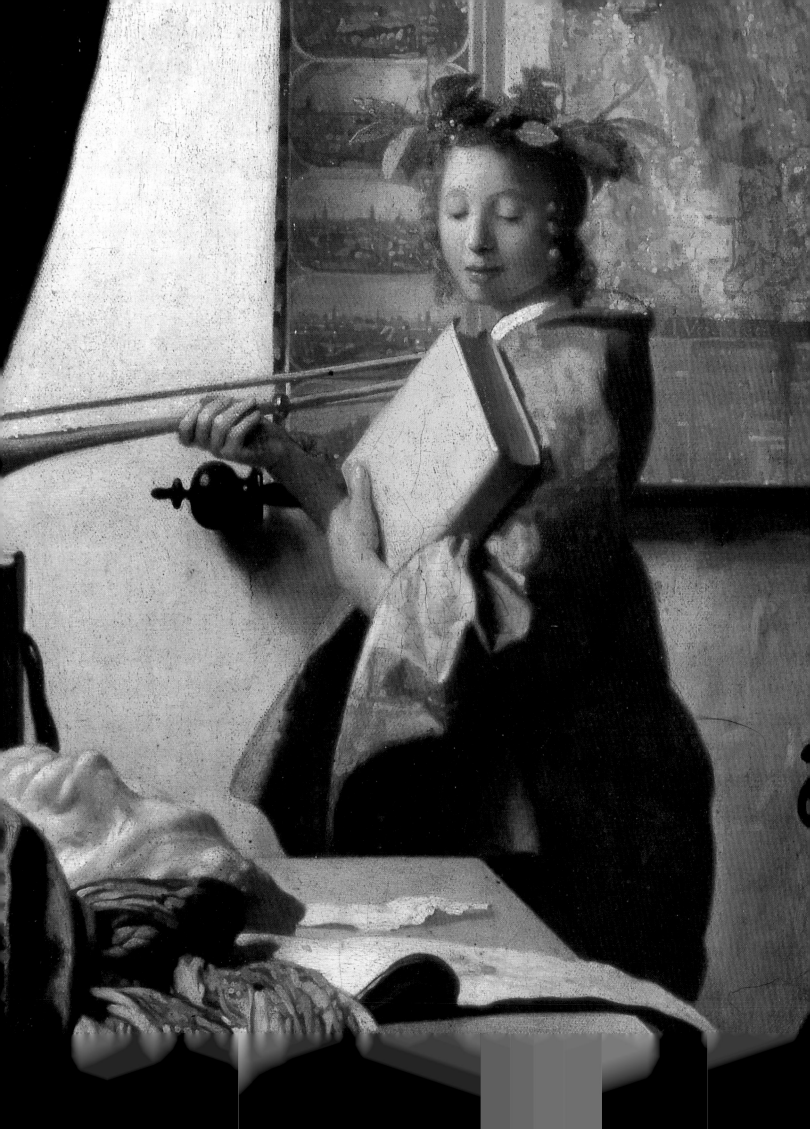

The Rediscovery of Vermeer

Vermeer and the Impressionists

Despite what has often been said in the past, Jan Vermeer van Delft was never completely forgotten. He is mentioned with praise in the 17th and 18th centuries; compared with other contemporary artists, though, this opinion met with little response.

It is only since the middle of the 19th century that his art has enjoyed an increasingly enthusiastic reception. It is no coincidence that this dawning interest in Vermeer went hand in hand with the rise of Impressionism, whose agenda was the rejection of a dark-toned, academic style of painting in favour of brightly-lit *plein-air* painting using a full, unmixed palette. It was the French socialist politician and journalist Théophile Bürger-Thoré (1806–1869) who initiated the new appreciation of Vermeer's art.

During his travels through England, Belgium, Holland and Switzerland, Bürger-Thoré concerned himself intensively with Dutch 17th-century painting and its everyday realism. He found that it corresponded to the aesthetic ideas expressed in the theories of Jules Champfleury (1821–1889) and Pierre-Joseph Proudhon (1809–1865), and in the art of the Barbizon school and Gustave Courbet (1819–1877).

A major plank in the French realist platform was that present-day social, cultural and political subject matter should determine content. This position was adopted by the Impressionists, though they aimed for radical change in terms of technique as well.

For the Impressionists, colour was a function of the response to light. Its brightness, tonality and density were dependent on the wavelength of light (or ethereal vibrations, as contemporary terminology had it). The Impressionists drew upon scientific theory, with the result that colour was seen no longer as intrinsic to things, but rather as a phenomenon subject to changes in the light. Furthermore, it was also particularly dependent on processes of perception in the eye of the beholder.

It was this theory of colour as a phenomenon of light that sensitized Bürger-Thoré's eye for what was aethetically distinctive in Vermeer: "In Vermeer, the light is never artificial; it is precise and natural, and not even a meticulous physicist could wish it to be more exact (…)". Elsewhere, he wrote: "It is to this precision of light that Vermeer owes the harmony of his colours too." One might say that Bürger-Thoré was discovering "modern" qualities in Vermeer, qualities in his artistic approach that had gone beyond the scope of the reception in his own day, but offered an ample purchase for appreciation two centuries later.

We now know that Vermeer used a camera obscura (p. 18) for most of his paintings. What is more, far from hiding the effects of the instrument, such as unfocussed outlines and the famous pointillist dots of light, he drew attention to them (cf. p. 86). This lends his paintings an "abstract" quality, since they do not

Camille Pissarro in a letter written in November 1882 to his son Lucien:
"How shall I describe these portraits by Rembrandt and Hals, and this view of Delft by Vermeer, these masterpieces which come so close to Impressionism?"

The Milkmaid (detail, see p. 65)

Dissolving shapes
Vermeer's use of the camera obscura tended to have the effect of dissolving the shape of what he was painting; Frans Hals achieved a similar effect (above), though his technique was quite different. Both artists were held in high esteem by the Impressionists.

pretend to be reproducing reality as it is, but show it as it is seen. In terms of Vermeer's work method, this translates as using a medium of reproduction to grasp the thing perceived – at a remove. We might even say that the camera obscura became a source of his style.

This hidden tendency to abstraction in Vermeer's technique was the cornerstone of his growing fame in the last third of the nineteenth century. Today, he is generally seen with Rembrandt and Frans Hals (the latter being another kindred spirit of the Impressionists) as the third great Dutch artist of the Golden Age.

Vincent van Gogh gave very close attention to Delacroix' theory of colour, and, like the Neo-Impressionists, studied the problems of complementary and contrasting colours in considerable detail. In a letter to Emile Bernard, written somewhere around 1888, he waxed lyrical on the subject of Vermeer's colour harmonies: "It is true that in the few pictures he painted, one can find the entire scale of colours; but the use of lemon yellow, pale blue and light grey together is as characteristic of him as the harmony of black, white, grey and pink is of Velázquez." In 1883, Henri Havard observed that many of the figures in Vermeer's paintings seemed merely to be "happy dabs of paint", commenting: "If they have any important part in the harmonic symphony at all, it is due to the shape they make, rather than the thought they express."

This new admiration for Vermeer is evident not only in the visual arts but also in classic Modernist literature. The most famous example is surely Marcel Proust's eulogy in *A la recherche du temps perdu*, in Part V, *La prisonnière*, where the death of Bergotte the writer is described. Shortly before, a critic has told the writer that he will be able to see Vermeer's *View of Delft* (p. 19), on loan from the Mauritshuis in The Hague for an exhibition. "At last he stood before the Vermeer, which in his memory was more radiant, even more different from anything else he was familiar with, but in which, thanks to the critic's article, he made out for the first time little blue-clothed figures, and furthermore realised that the sand was tinted a rosy colour, and finally discovered the costly material of the tiny yellow wall as well. His dizziness grew; he fixed his gaze – as a child would on a yellow butterfly it wants to catch – on that costly little corner of wall. 'That is how I should have written,' he reflected. 'My last books are too dry, I should have used more colour, should have made my language as precious in itself as this little yellow corner of wall is' (…)" For the writer nearing death, that detail becomes the very definition of art: "(…) this yellow corner of wall, done with such great skill and exquisite subtlety by a painter who remains unknown for all time and is only identified for convenience by the name Vermeer."

One could continue the list of quotations. Artists and theorists of nearly all avant-garde types of art have praised Vermeer's feeling for real colour and his principle of avoiding all unnecessary detail in his compositions. Cézanne's insistence that the artist should resist the literary became programmatic for avantgarde artists concerned primarily with questions of form; and it was little wonder, given this view, that Vermeer was felt to be free of anecdotal, narrative elements. André Malraux in particular emphasised that Vermeer's work completely lacked the "myth of narrative action" and "for the first time in the history of art (…) the subject of the painting had become an object of vision."[30]

The aesthetics of art as a mirror of culture

Those who have rediscovered Vermeer since the late 19th century have recognised that he was quietly innovative in his compositional technique. His predilection for balance; his method of simplifying complex structures to a few components (a method in which geometry played a key role); his treatment of light, which achieved effects of an almost *plein-airist* nature, rendering shadows no longer in greys but in a shimmer of colour; and his very paintwork, so distinct-

The Lacemaker (detail, see p. 63)

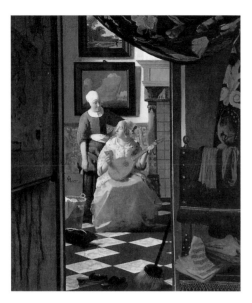
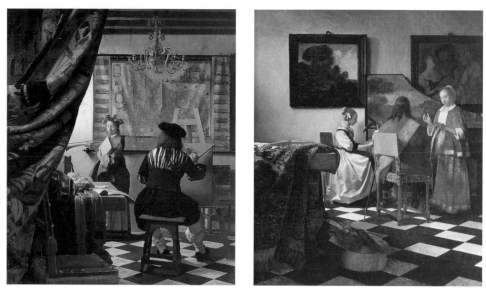

ively different from the fine, porcelain-smooth application then usual in the
Netherlands – all of these characteristics were the hallmarks of a style unusual
even in Vermeer's own day.

If we describe his work only in these terms, though, we risk missing how
very concrete Vermeer's representational art is. His subjects are by no means of
secondary importance. On closer inspection, we realise in fact that the formal
features of Vermeer's style derive from his way of placing people, objects and
rooms in contexts that lend social and cultural meaning. It is of the essence that
his strongly individualized figures tend to appear alone or almost alone, busy at
everyday tasks, reading letters or pouring milk. There is no bustle, tension or
agitation of the kind typical of Dutch narrative genre paintings of the period.
The facial expressions of Vermeer's people are not distorted grimaces dictated
by affect. His figures, mainly women, seem almost free of passion, not in any
sense of being emotionally unresponsive or insensible but in a sense of masking
their feelings rather than thrusting them upon us.

In his age, Vermeer was almost unrivalled in his ability to address by visual
means the moral agenda drawn up by thinkers such as Gracián or Montaigne.
He too was concerned to define people in their individuality, to preserve a pri-
vate domain for the affairs of the spirit, and to place limits upon communica-
tion.[31] It might not be going too far to see the tables that so often appear in the
foregrounds of his interiors, with carpets or curtains draped across them, as sym-
bolic: though it is only a prop, the table nonetheless denotes a boundary, and im-
poses distance between ourselves and the private realm we are permitted to see.

Rhetoric is of diminished importance in Vermeer, though it does not al-
together disappear. Rather, it is frequently transformed into a barely perceptible
irony, as becomes clear if we consider the interplay between the central charac-
ters and visual quotations, so important for the overall meaning. In many of Ver-
meer's paintings there are pictures on the walls, pictures clearly related to the
protagonists and intended by the artist as *clavis interpretandi*[32], or aids to inter-
pretation. His conception of the visual image was evidently dialectic: while he
may at first glance seem indifferent to communicating the meaning of a paint-
ing, he does in fact supply discreet aids such as we can only make use of if we
have the necessary learning and can pick up allusions.

Vermeer was frequently inspired by sayings and moral adages, such as circu-
lated in large quantities in the illustrated emblem books of the time. In the six-
teenth century, when they first appeared, emblems were originally symbols de-

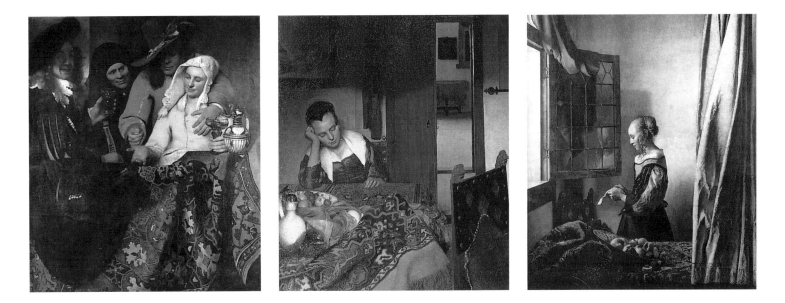

vised by humanists to suggest mysterious deeper meanings in things, and were difficult to interpret; but by the seventeenth century they had undergone lasting change. In the Netherlands they had become more accessible, and had taken on an unmistakable function as a source of popular education. They were meant to establish and consolidate a new moral code, and to shape and regulate individual conduct within emerging middle class society.

In the early modern era, the family unit was of central importance. Much of society's vital work was done in the family. Since the increasing division of labour was now tending to involve many men in work outside the home, women, as keepers of the house, found themselves with greater responsibility to bear and more tasks to perform. And the powers that were, as well as the authors of popular didactic tracts, tirelessly reminded them of these.

Most of Vermeer's paintings are about these domestic duties, but they also show the conflicts called forth in women by the imperatives of duty and virtue, so much at odds with the libidinous desires they were no longer permitted to express. We may be tempted to see Vermeer's method of encoding his meanings, and the concomitant impression of reserve and discretion his characters make, in purely aesthetic terms. But in fact they may be a response to this process of socio-cultural change. Arguably Vermeer's figures, rejecting the norms and demands of society, have been forced into isolation, and have withdrawn modestly – into silence.

Jan Vermeer (1632–1675): Chronology

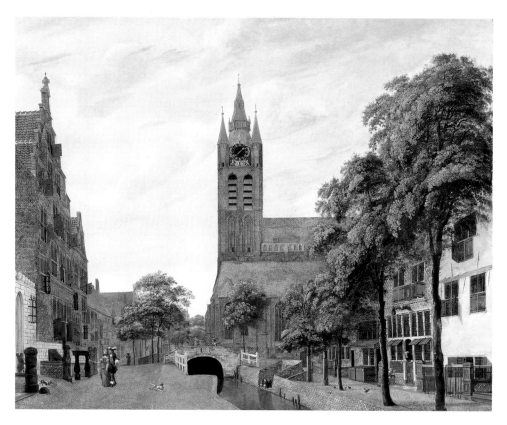

Jan van der Heyden (1637–1712):
View of Delft

1615 Reynier Janszoon Vos, by occupation a silk worker, marries Digna (or Dymphna) Baltens in Amsterdam. They then settle in Delft, where Reynier later (in 1641) purchases and runs the "Mechelen", an inn on the Market Square.

1622 Carel Fabritius (1622–1654) is born in Midden-Beemster.

1626 Jan Steen (1626–1679) is born in Leiden.

1631 Reynier Janszoon Vos starts dealing in paintings, and is enrolled in the Delft artists' guild, the Guild of St. Luke.

1632 Jan Vermeer, the second child of Reynier Janszoon Vos and Digna Baltens, is born. Their first child was a daughter. Antonie van Leeuwenhoek (1632–1723) is

born in Delft. Later in life he will be Vermeer's executor. He is a cloth merchant by trade, but starts amateur experiments with optical instruments such as the microscope. He make various discoveries, such as bacteria (1676), spermatozoa (1677) and red blood cells in fish.

1648 The Thirty Years' War comes to an end with the Treaty of Westphalia.

1650 William III of Orange is born.

1652 Vermeer's father dies. Carel Fabritius is made a member of the Guild of St. Luke.

1652–54 First Anglo-Dutch naval war.

1653 Vermeer marries Catharina Bolnes, the daughter of Maria Thins. The marriage is witnessed by the painter Leonaert Bramer.

1654 The Delft magazine explodes on 12 October, killing the painter Carel Fabritius. On 29 December, Vermeer is admitted as a Master Painter to the Guild of St. Luke.

1656 First dated work of Vermeer's (*The Procuress*, Dresden, Gemäldegalerie).

1657 Vermeer borrows two hundred guilders.

1662 Vermeer is elected as syndic (*hoofdman*) of the Guild of St. Luke.

1663 The French nobleman Balthazar de Monconys, an alchemist and lover of art, visits Vermeer and writes about this encounter in his Journal.

1665–67 Second Anglo-Dutch naval war.

1667 The Spanish Netherlands are occupied by Louis XIV. In response, the Nether-

Egbert van der Poel (1621–1664):
The Explosion of the Delft Magazine, c. 1654

lands form a triple alliance with England
and Sweden, thereby forcing Louis XIV
largely to abandon his conquests. Dirck van
Bleyswijck mentions Vermeer in his *Beschrij-
vinge der Staat Delft* (Description of Delft).

1668 Second dated work of Vermeer's (*The
Astronomer*, Paris, Musée du Louvre).

1669 Third dated work of Vermeer's (*The
Geographer*).

1670–71 Vermeer is re-elected as syndic
of the Guild.

1670 Vermeer's mother dies, leaving him
his parents' inn, the "Mechelen".

1672 Louis XIV invades the Netherlands
from the Lower Rhine with an army of
100,000 men. The only way the Netherlands
can defend themselves against the advancing

troops is to open the dykes and flood land.
Vermeer lets the "Mechelen" for 180 guilders
a year. He also journeys to The Hague, where,
together with Johannes Jordaens, he is em-
ployed by the Elector of Brandenburg to value
Italian paintings.

1675 Vermeer travels to Amsterdam to bor-
row one hundred guilders. He dies in Decem-
ber, and is buried in the Oude Kerk in Delft.
He is survived by eleven under-age children,
eight of whom are still living at home. He is
deeply in debt at the time of his death, and
as a result his widow has no alternative but
to be declared bankrupt. Delft city records
show that Van Leeuwenhoek is appointed as
curator of his estate on 30 September 1676.

1688 Vermeer's widow, Catharina Bolnes,
dies.

Index of Works

Oil on canvas, 42.5 x 38cm
Washington (DC), © 1992 National Gallery of Art,
Widener Collection

62
Caspar Netscher:
The Lacemaker, 1664
Oil on canvas, 34.3 x 28.3cm
London, Wallace Collection
Reproduced by permission of the Trustees of the
Wallace Collection

63
The Lacemaker, c. 1669–70
Oil on canvas, 24.5 x 21cm
Paris, Musée du Louvre

64
Woman with a Water Jug, c. 1664–65
Oil on canvas, 45.7 x 40.6cm
New York, The Metropolitan Museum of Art,
Gift of Henry G. Marquand, 1889.
Marquand Collection. (89.15.21)

65
The Milkmaid, c. 1658–60
Oil on canvas, 45.4 x 41cm
Amsterdam, Rijksmuseum

68
Girl with a Pearl Earring, c. 1665
Oil on canvas, 45 x 40cm
The Hague, Mauritshuis

69
Jan van Eyck:
Man Wearing a Red Turban, 1433
Oil on wood, 25.7 x 19cm
London, The National Gallery,
reproduced by courtesy of the Trustees

70
Head of a Girl, c. 1666–67
Oil on canvas, 44.5 x 40cm
New York, The Metropolitan Museum of Art,
Gift of Mr. and Mrs. Charles Wrightsman, in memory
of Theodore Rousseau, Jr., 1979. (1979.396.1)

71
Girl with a Flute, c. 1666–67
Oil on wood, 20 x 17.8cm
Washington (DC), © 1992 National Gallery of Art,
Widener Collection

73
Girl with a Red Hat, c. 1666–67
Oil on wood, 23.2 x 18.1cm
Washington (DC), © 1992 National Gallery of Art,
Andrew W. Mellon Collection

74
The Geographer, c. 1668–69
Oil on canvas, 53 x 46.6cm
Frankfurt/M., Städelsches Kunstinstitut

75
Jan Verkolje:
Antoni van Leeuwenhoek, undated
Oil on canvas, 56 x 47.5cm
Amsterdam, Rijksmuseum

76
The Astronomer, c. 1668
Oil on canvas, 50.8 x 46.3cm
Paris, Musée du Louvre

79
Caspar Netscher:
The Locket (detail), c. 1665–68
Oil on canvas, 62 x 67.5cm
Budapest, Szépmüvészeti Múzeum

80
Allegory of Faith, c. 1671–74
Oil on canvas, 114.3 x 88.9cm
New York, The Metropolitan Museum of Art,
Bequest of Michael Friedsam, 1931.
The Friedsam Collection. (32.100.18)

83
The Art of Painting, c. 1666–73
Oil on canvas, 130 x 110 cm
Vienna, Kunsthistorisches Museum

92
Jan van der Heyden:
View of Delft
Oil on wood, 55 x 71cm
© The Detroit Institute of Arts,
Gift of Mr. and Mrs. Edgar B. Whitcomb

93
Egbert van der Poel:
The Explosion of the Delft Magazine, c. 1654
Delft, Gemeente Musea

Notes

1. Biography of Vermeer: Cf. recent research by J. M. Montias, Vermeer and his Milieu, Princeton, 1989. Prices of paintings: Cf. A. Hauser, Sozialgeschichte der Kunst und Literatur, Munich, 1972, p. 507f, and J. M. Montias, Artists and Artisans in Delft, Princeton, 1982, p. 196f.
2. See P. C. Sutton, in: Cat. Masters of 17th Century Dutch Landscape Painting, Amsterdam, 1987
3. Cf. Cat. Perspectives. Saenredam and the architectural painters of the 17th century. Rotterdam, 1991, no. 30, pp. 168ff.
4. Re Titian's painting "Diana and Actaeon", cf. H. E. Wethey: The Paintings of Titian, vol III. The Mythological and Historical Paintings, London, 1975, pp. 78ff, no. 9.
5. Cf. J. Nash: Vermeer, London, 1991, p. 46.
6. For more information on the history of the "bordeeltje", see K. Renger, Lockere Gesellschaft, Berlin, 1970.
7. On "acedia", cf. G. Ogier, De seven hoofd-sonden […] vermakelyck en leersaem voor-gesteld. Amsterdam, 1682 (cover engraving by Caspar Bouttats).
8. Cf. C. Brown: Holländische Genremalerei im 17. Jahrhundert, Munich, 1984, p. 88 and illus. p. 31).
9. Cf. J. A. Welu: "Vermeer: His Cartographic Sources", in: The Art Bulletin LVII, 1975, pp. 529–547.
10. Cf. Cat. Die Sprache der Bilder, Brunswick, 1978, p. 166.
11. Cf. Jan Baptista van Helmont's (1577–1644) medical treatises "Ortus medicinae" (Amsterdam, 1648; 2, 1652) and "Opuscula medica inaudita" (Cologne, 1648).
12. Cat. Sprache der Bilder (see note 10), p. 117.
13. Cf. W. Tatarkiewicz, Geschichte der Ästhetik, vol. III. Die Ästhetik der Neuzeit, Basle/Stuttgart, 1987, pp. 265ff.
14. Cf. A. Robertson/D. Stevens (eds.): Geschichte der Musik, vol II, Renaissance und Barock, Herrsching, 1990, pp. 236ff.
15. Is this woman really pregnant, as is suggested repeatedly in books on Vermeer? It is possible that what she is wearing is a crinoline farthingale. These bell-shaped skirts were in fashion at the time, as is confirmed in a 1641 painting by Johannes Verspronck, which features a girl wearing such a dress (Amsterdam, Rijksmuseum). Farthingales were called "vertugalles" or "vertugadins" (chastity skirts).

16. Cf. A. Henkel/A. Schöne (eds.): Emblemata, Stuttgart, 1967, col. 1292.
17. P. Chaunu: Europäische Kultur im Zeitalter des Barock, Munich/Zurich, 1968, p. 259. Also cf. J.-L. Flandrin: Familien. Sozologie – Ökonomie – Sexualität, Frankfurt/M., 1978.
18. Cf. an important source: Peter Müller: Dissertatio Juridica de litteris amatoriis quam praeside Petro Müllero… 1679 publicè ventilandam exhibet Bernhard Pfretzschner, Gera/Jena 1690 (makes frequent references to writings on marriage, e.g. J. L. Vives, D. Covarrubias y Leyva, and also to emblems whose significance has been clearly established).
19. Cf. E. de Jongh: Pearls of virtue and pearls of vice, in: Simiolus 8, 1875/76, pp. 69ff. Cf. here in particular p. 81, illus. 9.
20. Servants in 17th-century households were divided according to their duties and positions. In contrast to cowmaids, who worked in the stables and outside the house, the milkmaid's tasks lay within the house. She had to manage the rather complex dairy. Her duties included producing curds, butter and cheese, cleaning all the necessary utensils, such as the milk churns and muslin cloths, and keeping the dairy clear of vermin (one way of doing this was to fumigate it with myrrh, incense and various herbs). Given the importance of milk products, it is not surprising that milk took on an almost religious importance.
21. E. Panofsky: Early Netherlandish Painting. Its Origins and Character, Cambridge (MA), 1953, vol I, illus. 213, Plate 97.
22. Cf. Tatarkiewicz (see note 16), p. 152.
23. Cf. E. de Jongh (see note 19), p. 77.
24. Sebastian Brant: Das Narrenschiff, ed. by C. Traeger, Frankfurt/M., 1980, pp. 187ff.
25. On the history of 17th-century astronomy, cf. A. C. Crombie: Von Augustinus bis Galilei. Die Emanzipation der Naturwissenschaft, Munich, 1977, pp. 198ff. M. Boas: The Scientific Renaissance 1450–1630, pp. 287ff. The standard work about the period is L. Thorndike: A History of Magic and Experimental Science, New York, 1923–41, in particular vol. 6. Also useful is W. Durant: Vom Aberglauben zur Wissenschaft (Kulturgeschichte der Menschheit, vol. 13), Frankfurt/Berlin/Vienna, 1982, pp. 38ff. (astronomy), pp. 42ff. (geography).
26. Cf. J. A. Welu: "Vermeer's Astronomer: Observations on an open book", in: The Art Bulletin LXVIII, No. 2, June 1986, pp. 263–67.
27. Cf. H. Biedermann: Handlexikon der magischen Künste, Munich/Zurich, 1976, pp. 185ff.
28. Cf. A. Wheelock jr.: Jan Vermeer, New York, 1988, p. 118; Nash (see note 5), p. 108.
29. Further information on this painting in H. U. Asemissen: Jan Vermeer, Die Malkunst. Aspekte eines Berufsbildes, Frankfurt/M., 1988. The interpretation of this painting given here, which breaks with common theory, is based on a study by the author, which should be published in 1993.
30. The quotations from Bürger-Thoré, Van Gogh, Havard and Malraux are taken from: G. Aillaud et al. Vermeer, Geneva 1987, p. 209 ff. (Würdigungen), and I. Schlégl/P. Bianconi: Das Gesamtwerk von Vermeer. Luzern/Freudenstadt/Vienna, 1967, pp. 10ff. The quotations from Proust are taken from: A la recherche du temps perdu. Vol. V: La prisonnière. Cf. auch Yann le Pichon (avec la collaboration de Anne Borrel): Le musée retrouvé de Marcel Proust. Paris 1990. P. 84–86. –Zu Bürger-Thoré cf. A Blankert: Vermeer of Delft. Oxford, 1978, pp. 67ff. On the camera obscura as the "source of style" cf. S. Alpers: Kunst als Beschreibung. Cologne, 1985, p. 87.
31. On morality, cf. G. Schröder: "Gracián und die spanische Moralistik", in A. Buck (ed.): Renaissance und Barock II. (Neues Handbuch der Literaturwissenschaft, vol. 10), Frankfurt/M., 1972, pp. 257ff.
32. On "claves interpretandi", cf. R. Keyszelitz: Der "Clavis interpretandi" in der holländischen Malerei des 17. Jahrhunderts, doctoral thesis, Munich, 1956.

Acknowledgements

The publishers would like to thank all the museums, galleries, collectors and photographers that have helped us produce this book. In addition to those named in the notes, our thanks to those below: Jörg P. Anders (35, 57); Blauel/Gnamm – Arthothek (74); Bullaty Lomeo/The Image Bank (10); Richard Carafelli (52); English Heritage (47); Museumsfoto B. P. Keiser (33); © Mauritshuis, The Hague (16, 19, 22); Photo Meyer KG (83); © Photo R.M.N. (63, 76); Gordon H. Robertson (41); Sächsische Landesbibliothek Dresden/Deutsche Fotothek (25, 50 left); Norbert Schneider (36 bottom, 38 bottom, 44 bottom); Jac. T. Stolp, Utrecht (18 centre right); Daniël van de Ven, © Mauritshuis, The Hague (68); Ed van Wijk, Delft (18 top right).

In this series:

- Arcimboldo
- Bosch
- Botticelli
- Bruegel
- Cézanne
- Chagall
- Christo
- Dalí
- Degas
- Delaunay
- Duchamp
- Ernst
- Gauguin
- van Gogh
- Grosz
- Hopper
- Kahlo
- Kandinsky
- Klee
- Klein
- Klimt
- Lempicka
- Lichtenstein
- Macke
- Magritte
- Marc
- Matisse
- Miró
- Monet
- Mondrian
- Munch
- O'Keeffe
- Picasso
- Rembrandt
- Renoir
- Rousseau
- Schiele
- von Stuck
- Toulouse-Lautrec
- Turner
- Vermeer
- Warhol